POSTCARD HISTORY SERIES

Newfound Lake

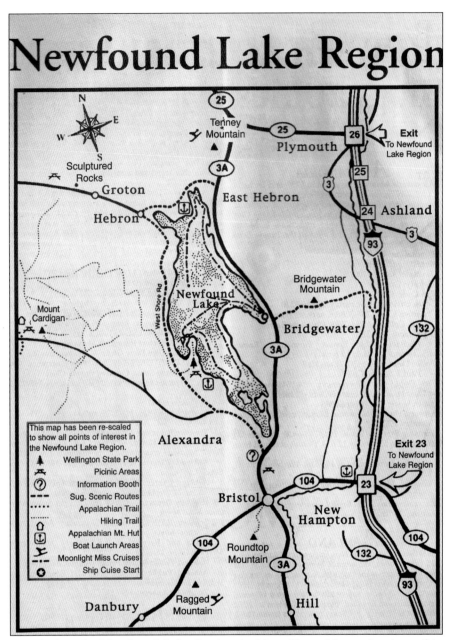

Newfound Lake Region

This map depicts the Newfound Lake Region in New Hampshire and points of interest. (Authors' private collection.)

ON THE COVER: This postcard image depicts the foot of Newfound Lake in the 1920s. Prince's Place, now Silver Shores Condominiums, is seen in the foreground. Mayfair Lodge, now Swissview Condominiums, is to the far left and to the right of what was Darling's real estate office, now the Big Catch Restaurant. In the trees above is a glimpse of Cliff Cottages, now the Ledge Water Steak House. (Authors' private collection.)

POSTCARD HISTORY SERIES

Newfound Lake

Jeanne Mulhern Hoflen and Kent G. Hoflen

ARCADIA
PUBLISHING

Published by Arcadia Publishing
Charleston, South Carolina

Printed in the United States of America

Library of Congress Control Number: 2011932560

For all general information contact Arcadia Publishing at:
Telephone 843-853-2070
Fax 843-853-0044
E-mail sales@arcadiapublishing.com
For customer service and orders:
Toll-Free 1-888-313-2665

Visit us on the Internet at www.arcadiapublishing.com

This book is dedicated in memory of my parents, Philip and Barbara Mulhern, who loved Newfound Lake more than any other place in the world.

CONTENTS

ACKNOWLEDGMENTS

Having collected vintage postcards of Newfound Lake and the surrounding areas for quite some time, we were delighted to learn that Arcadia Publishing had a special series of books designed to showcase these historic postcards for all to enjoy. We are thrilled to be a part of this unique series of books and feature our beloved Newfound Lake.

There are simply no words to express our profound gratitude to our family members, Carol and Kevin Henderson, our wonderful children Andria and Eric, and our lifelong friends John McCaffery and Ronnie St. Cyr for their unwavering support and assistance in this unique family endeavor.

We also deeply appreciate all of the assistance and information so generously provided by the local historical societies, historians, libraries, and old-timers. To all of you who gave so freely of your time to ensure that our book contained the most accurate information and history, we extend our deepest thanks and appreciation—especially to George Morris of the Grafton County Registry of Deeds, who made hundreds of treks to the basement to locate archived historical documents; Lucille Keegan at the Bristol Historical Society; Judy Faran at the Bridgewater Historical Society; author Kenneth E. Bingham; Jim Nute of the Mayhew Program; John O'Connor; John and Dottie Kaczowka; Paul and Tami Zareas; and our newfound friend Jon Hoyt.

This book is dedicated to Philip and Barbara Mulhern, who worked so hard to provide our family and extended family with a special summer place at Newfound Lake. Our cottage—where everyone was told to "leave your troubles at the door and pick them up on your way out"—has provided a lifetime of special events, weddings, family reunions, and good, old-fashioned, carefree summer fun. We hope to continue our family's tradition of "caring and sharing" at Newfound Lake for many generations to come.

We extend our eternal gratitude to the late Elaine Maloof McCaffery, who was like a mother to us and inspired us all. Her love, kindness, generosity, wisdom, fascinating stories, and unsurpassed culinary delights shared on the beach at the foot of Newfound Lake brought so much joy into our lives and will never be forgotten.

While most of the images in this book are from our private collection of vintage postcards, a special thank-you goes to the contributors of postcards and photographs whose initials appear under the images they provided: Appalachian Mountain Club (AMC), Beth Christiansen (BC), Bridgewater Historical Society (BHS), Bristol Historical Society (BrHS), Carol A. Henderson (CAH), Camp Berea (CB), Camp Mowglis (CM), Camp Onaway (CO), Camp Pasquaney (CP), Coppertoppe Inn (CI), Doreen Holden (DH), Elizabeth Burkush (EB), Garyln Manganiello (GM), Harold B. Waring (HBW), Jon Hoyt (JH), Jerry Nialetz (JN), Kenneth E. Bingham (KEB), Meadow Wind Bed and Breakfast (MWBB), Newfound Bed and Breakfast (NBB), Roger H. Emerson Jr. (RHE), Ragged Mountain Resort (RMR), Ronald St. Cyr (RSC), Six Chimneys Bed and Breakfast (SCBB), the Whipple House (TWH).

INTRODUCTION

Newfound Lake is located in the Lakes Region in central New Hampshire and has about 22 miles of shoreline. Containing 4,106 acres at 590 feet above sea level, the lake is about 7 miles long and 2.5 miles wide and borders the towns of Alexandria, Bridgewater, Bristol, and Hebron, each with a unique charm of its own. It is one of the largest lakes located entirely in the state of New Hampshire and has four islands—Mayhew Island, Belle Island, Cliff Island, and Loon Island. It is reported to be one of the cleanest lakes in the world thanks to its many underground springs, which refresh the lake constantly. Originally inhabited by Pemigewasset Indians who moved to Canada around the year 1750, Newfound Lake was originally called Pasquaney Lake, which means "the place where birch bark for canoes is found." The name was changed to New Found Pond and ultimately became Newfound Lake.

Newfound Lake has always been a haven for avid fisherman, and a record was set in April 1958 for a 28.5-pound, 38.5-inch lake trout. Newfound Lake was first stocked with 28 landlocked salmon in 1866 when the New Hampshire Fish and Game Commission was created. Smelt and blue-backed trout were added in the 1870s, and sailing, whitefish, and lake trout were added in the 1880s. A hatchery was built in 1889 by the dam at the outlet of the lake, but a better hatchery, which no longer exists, was built on the Tilton Brook in Bridgewater. To this day, Newfound Lake is considered one of the finest fishing spots around.

Having spent decades at our family cottage on Newfound Lake, we no doubt have a long-standing love and appreciation for the natural beauty of Newfound Lake and the majestic mountain backdrop. My husband and coauthor, Kent, and I were married in 1983 at Our Lady of Grace Chapel at the foot of the lake and had a memorable wedding reception at the church dance hall, which my dearly departed father, Philip Mulhern, had helped to maintain and repair for decades. Our love of this special place was the reason we chose to spend our honeymoon at Newfound Lake as well.

Having compiled an assortment of historic postcards of the Newfound Lake area, we decided one day that these amazing images of this special place were just too interesting to keep hidden away in a shoebox. So it was in that moment that the idea for this book project about Newfound Lake was born. Whether you are a longtime resident, a passing tourist, a summer resident, or a day-tripper, we hope that you find this book to be an enjoyable historic picture guide. It is our hope that you will be able to locate these fascinating places using our easy reference information, then find that amazing place and truly experience the wonder of that magical moment in time where the past meets the present.

We have included everything a visitor could possibly need for a memorable getaway to Newfound Lake—historic lodging, fantastic restaurants, and taverns steeped in history, legendary summer camps, and interesting places to visit as well as unsurpassed picturesque locations to simply take in and enjoy. While there are many other fine establishments and historic sites in the Newfound Lake area that are not included in our book, we encourage our readers to get out and explore all of these other wonderful places on their own so they can truly appreciate all that makes Newfound Lake so special.

Kent and I will be celebrating 30 years together in 2012, so this book is a unique opportunity for us to commemorate this milestone in our lives and to relive our treasured memories of Newfound Lake. While our lives and the world in general have changed greatly in the last 30 years, Newfound Lake has remained remarkably the same with its crystal clear waters, majestic mountains, quaint New England cottages, and fresh, invigorating mountain air. Even if this is your first visit here, you will no doubt agree that it has a timeless and unparalleled charm and allure. It truly is "New Hampshire's best-kept secret"—or used to be, until now!

One

THE TOWNS

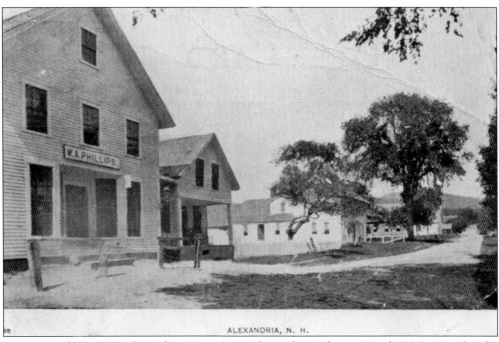

ALEXANDRIA, N. H.

Incorporated in 1782, Alexandria, New Hampshire (shown here around 1900), is said to be named after Alexandria, Virginia, where the first Colonial Governors' Conference was held in 1755 at the onset of the French and Indian War. Luther C. Ladd, born in Alexandria, New Hampshire, was the first enlisted soldier to die in the Civil War. In 1860, Alexandria's population was 1,253—more than Manchester, New Hampshire, at that time. In 2010, Alexandria's population was 1,613. More information about the town of Alexandria can be found on the Web at www.alexandrianh.com.

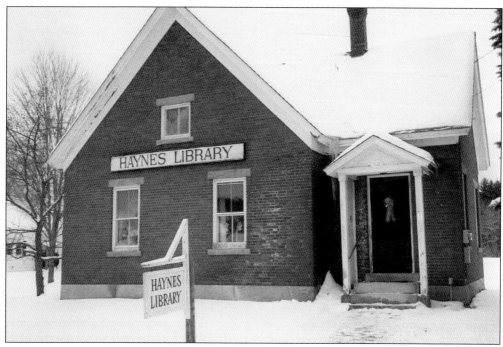

Located at 33 Washburn Road in Alexandria, Haynes Memorial Public Library was built in 1887. This was shortly after Dr. Timothy Haynes bequeathed the sum of $1,000 to the town for a library fund so long as the town also raised $1,000 toward the library. The building remains relatively unchanged and still has no running water. It is open year-round on Mondays only from 1:30 p.m. to 4:30 p.m. and 7:00 p.m. to 8:00 p.m.

The Bridgewater Town Hall, located at 297 Mayhew Turnpike (Route 3A) in Bridgewater, held its first meeting here on March 14, 1989. In 1830, Bridgewater's population was 783, and in 2010, its population was 1,083. Bridgewater was named after Bridgewater, Massachusetts, because most of its original settlers were from there. More information about the town of Bridgewater can be found on the Web at www.bridgewater-nh.com. (BHS.)

The Town House at the top of Bridgewater Hill Road in Bridgewater was built in 1806, with a blacksmith shop and store erected nearby. The store was owned and operated by Ichabod Bartlett, who reportedly ran a successful store in Bristol called Follansbees. Old Home Week has been celebrated here annually since 1899, when New Hampshire governor Frank Rollins created the event as a way to celebrate each community's roots. (BHS.)

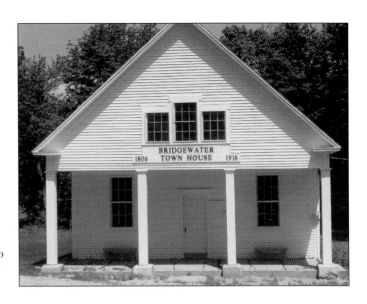

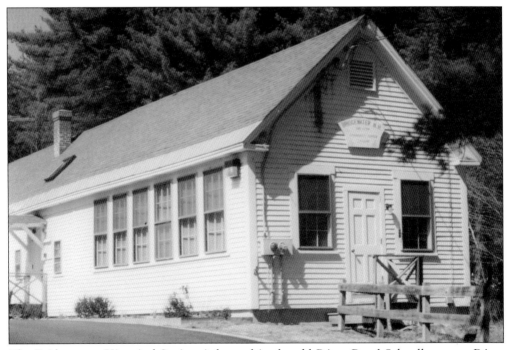

The Bridgewater Historical Society is located in the old River Road Schoolhouse on River Road in Bridgewater. It is open by appointment only, with meetings once a month, and new members are always welcome. This is now the town clerk's office as well. For more information about the Bridgewater Historical Society, readers can contact the town hall at www.bridgewater-nh.com. (BHS.)

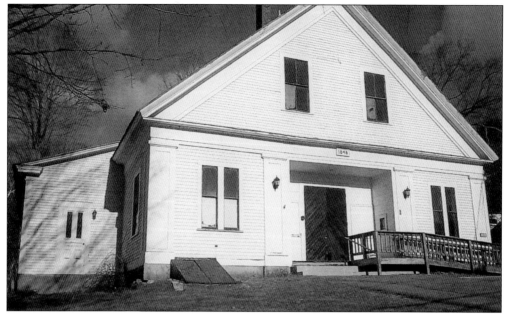

Located on Summer Street near School Street, Bristol's Town House was built in 1849, and the first town hall meeting was held here in March 1850. The top floor was used as an armory for local militia, and this building was the center of activity back then—hosting musicals, plays, patriotic rallies, dances, suppers, and other activities. Bristol was incorporated in 1819. In 1830, Bristol's population was 799, and in 2010, its population was 3,054. (BrHS.)

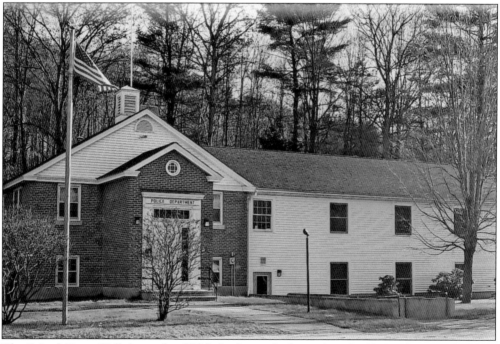

The Bristol Town Hall, located at 230 Lake Street, is shown here in 1968. The town hall was built in 1957 by R.P. Williams and Co., and it contains the police department and other town offices. For more information, readers can visit www.townofbristolnh.org. (DH.)

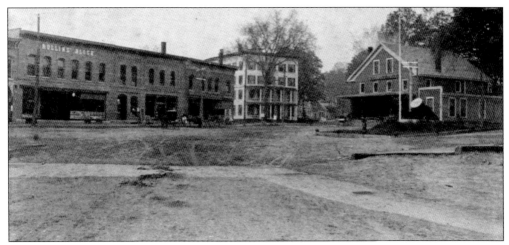

Central Square in Bristol is shown here. The hotel was destroyed by fire in the early 1900s, but the other buildings have not changed much in the past 100 years and now contain antique stores, restaurants, and other businesses. The Bristol Village was a major trading center for the neighboring towns, including Alexandria, Bridgewater, Groton, Hebron, and New Hampton. The whole west side of Central Square burned to the ground the night before July 4, 1861, except for one brick building later called Lidstone's. This was the worst fire in the town of Bristol's entire history, and consequently, all of the buildings in the square were constructed of brick, most likely made with locally manufactured Bristol brick, and are still standing today.

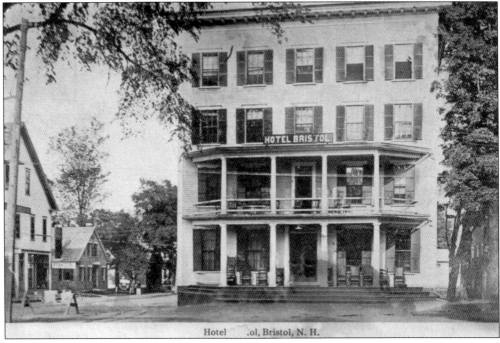

Hotel Bristol was located at the corner of Pleasant Street and the old Main Street in Central Square in Bristol and offered excellent accommodations with 41 rooms available for guests. Charles Henry Prescott became the proprietor in 1901.

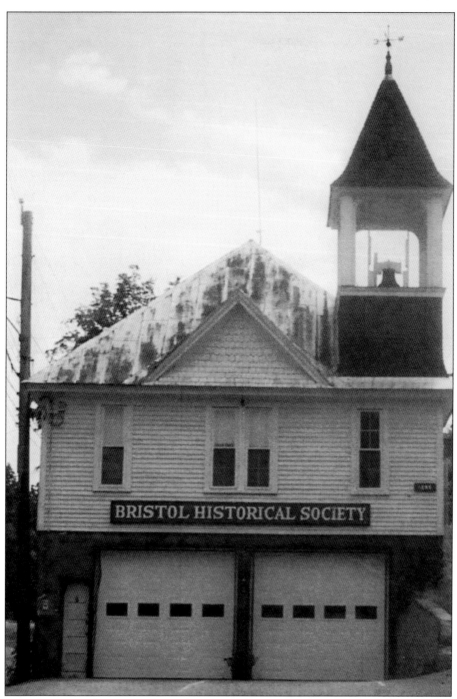

The Bristol Historical Society is located in the Old Engine House at the corner of South Main and High Streets. The Engine House was built in 1861 after the entire west side of Central Square was destroyed by fire. Bristol Historical Society was formed in 1965 to preserve the history of Bristol. The museum is open to the public, and new members interested in the history of this unique town are always welcome. For more information, readers can visit www. bristolhistoricalsociety.com. (BrHS.)

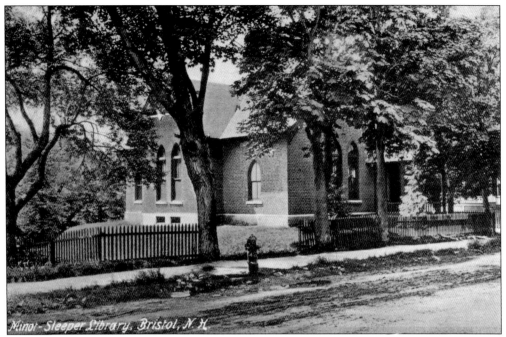

The Minot-Sleeper Library, located at 35 Pleasant Street in Bristol, was opened to the public on February 28, 1885, by the generous gifts of Hon. Solomon S. Sleeper, a colonel in the New Hampshire Militia and successful businessman, and Judge Joseph Minot, a successful lawyer and financier who donated the library building. This postcard is postmarked 1909. For more information about the Minot-Sleeper Library, readers can visit www.townofbristolnh.org.

Hebron Village is located at the northwestern part of Newfound Lake. Hebron was formed in 1791 and incorporated in 1792 from the now extinct town of Cockermouth and a part of what was known as West Plymouth. Hebron's population was 538 in 1830 and 602 in 2010. This postcard is postmarked 1914. For more information about the town of Hebron, readers can visit www.hebronnh.org.

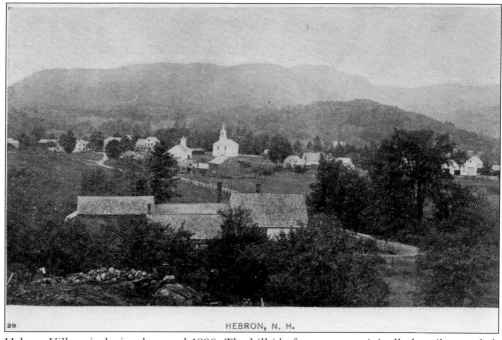

HEBRON, N. H.

Hebron Village is depicted around 1890. The hillside farms were originally heavily wooded, but many of the trees were cut down for firewood and used for making furniture and tools needed for survival. The maple trees also provided plenty of sugar, and these items were traded at the Hebron Village Store in exchange for other necessary supplies.

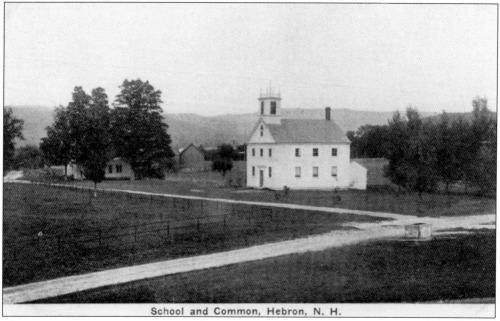

School and Common, Hebron, N. H.

The schoolhouse and common in Hebron are shown around 1900. Hebron was named after Hebron, Connecticut, where many of the settlers were originally from. For more information about the history of Hebron, readers can visit the Hebron Historical Society website at www.hebronhistsoc.org.

Two

SOUTH SHORE
(FOOT OF THE LAKE)

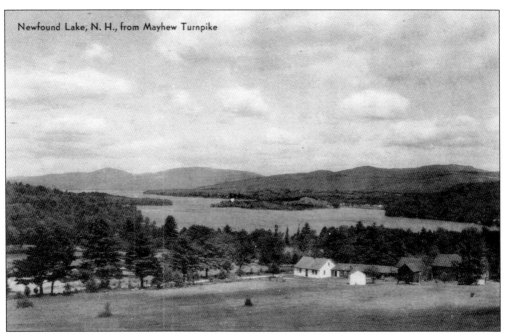

Newfound Lake, N. H., from Mayhew Turnpike

This postcard shows sweeping views of Newfound Lake and the Sleeper farm, which was previously the Ordway farm. The farm property went all the way to the shores of Newfound Lake, which was the primary source of water for the farmers, their livestock, and their crops, not to mention a tremendous source of freshwater fish year-round. This postcard is postmarked 1910. The south shore is commonly referred to as the "foot of the lake" or the "south end."

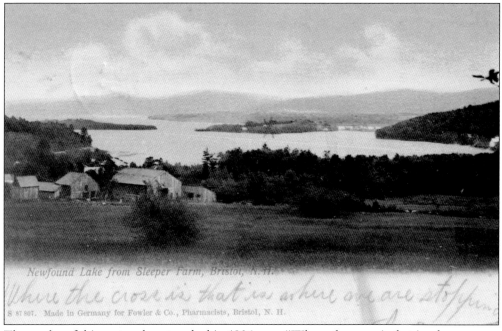

Newfound Lake from Sleeper Farm, Bristol, N. H.

S 87 807. Made in Germany for Fowler & Co., Pharmacists, Bristol, N. H.

The sender of this postcard postmarked in 1906 says, "Where the cross is that is where we are stopping." This refers to what is known as Pike's Point at the southern end of Newfound Lake, which was named after Edwin T. Pike, who owned a farm on the east shore of Newfound Lake in the 1800s.

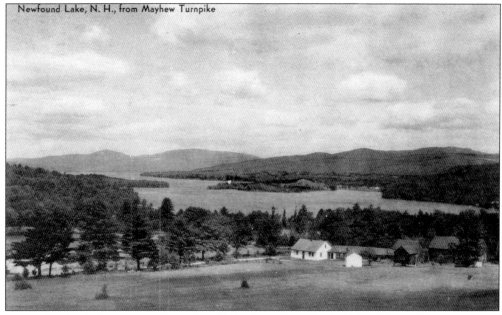

Newfound Lake, N. H., from Mayhew Turnpike

Postmarked in 1941, this view from the old Mayhew Turnpike in Bristol shows the old Sleeper/ Ordway farm, which was originally a 100-plus-acre farm on the shores of Newfound Lake. When the dam at the outlet of the lake was built in 1858, it raised the lake by eight feet, resulting in the farmer's shoreline being flooded to this day. Many other shorefront property owners now have land extending out almost 100 feet under the lake as a result.

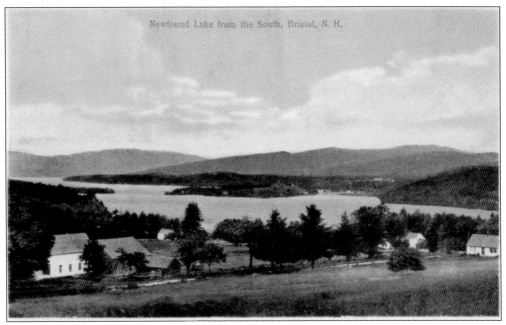

This view of the old David Sleeper farm on the former Mayhew Turnpike, now South Main Street in Bristol, shows panoramic views of Newfound Lake with Tenney Mountain in the background and Pike's Point to the center. This farm had over 1,000 feet of shorefront at the foot of the lake, which became Prince's Beach in the 1920s.

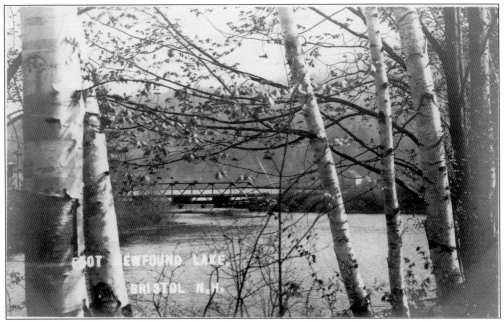

The bridge at the outlet of Newfound Lake on the southwest shore was built in 1893 at a cost of $725. This iron bridge replaced the original c. 1824 bridge that was then called Dimond's Bridge for Thomas Dimond, who lived on the west bank of Newfound River at that time. Of note is the c. 1910s boathouse to the right of the bridge on the shore of what is now the Newfound Lake House.

Shown here is what is known as the Gatekeepers House by the dam at the outlet of Newfound Lake on West Shore Road. This property was a large farm previously owned by George Sweetnam in the early 1900s, which extended along Newfound River across the road to the shores of Newfound Lake.

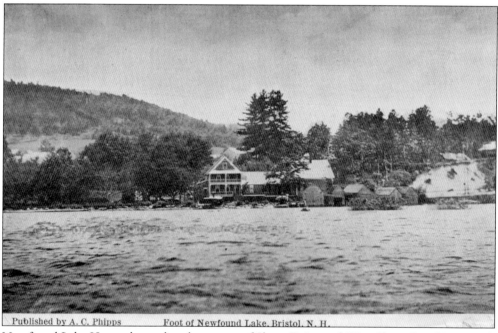

Published by A. C. Phipps Foot of Newfound Lake, Bristol, N. H.

Newfound Lake House, located at the corner of Shore Drive and West Shore Road in Bristol, was formerly known as the Landlocked Salmon House, owned and operated by Capt. Samuel Hentall in the late 1800s and early 1900s. This was a popular summer resort with numerous boathouses and docks offering lodging and boat rides in steamboats to paying customers. This photograph is from the 1910s.

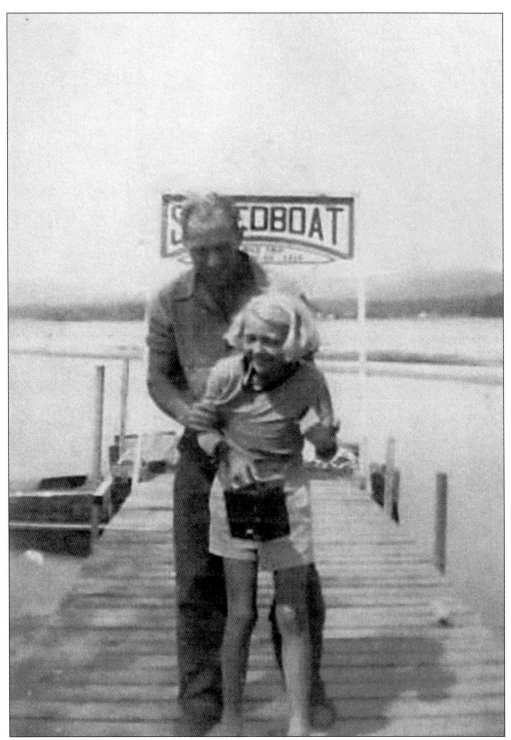

Newfound Lake House offered boat rides to paying passengers on its large private boat dock from the 1880s to the 1950s. Irwin Faller and his niece Elizabeth Burkush are seen here on their dock around the 1930s. (EB.)

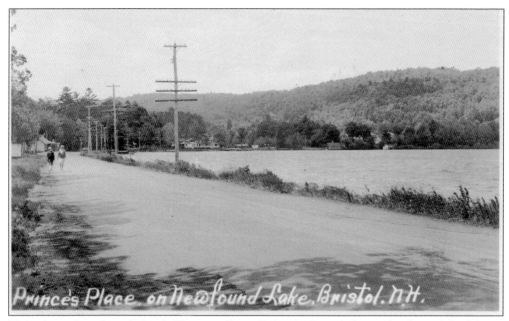

Prince's Place on Newfound Lake, Bristol, N.H.

This view taken from Prince's Place on Shore Drive in Bristol shows the foot of the lake in about the 1920s, with Newfound Lake House and a boathouse to the left of the bridge and docks, boats, and a boat livery along the southwestern shore as well as boathouses on the shore to the right of the bridge.

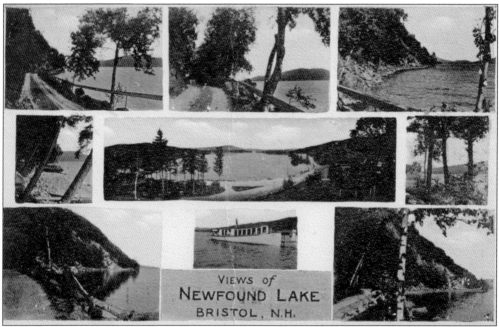

VIEWS of
NEWFOUND LAKE
BRISTOL, N.H.

This multi-view postcard postmarked in 1916 shows the *Stella Marion* and the foot of Newfound Lake, where there was a boat livery with docks by the Newfound Lake House near the bridge at the outlet of the lake on Pond Road (now called Shore Drive). Locally handcrafted rowboats and canoes were rented and sold here in the 1890s and early 1900s, and paying passengers enjoyed excursions on the lake in the *Stella Marion*.

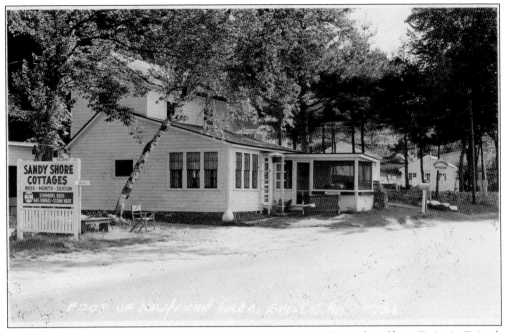

Shown here around 1950, the Sandy Shore Cottages property, located on Shore Drive in Bristol, was a private lakefront vacation spot consisting of this main house/office, six 2-bedroom, 1-bathroom rental cottages, and a large, sandy private beach with docks and rafts. This "office" was purchased by Philip and Barbara Mulhern in 1968 and has been the authors' family cottage since. (CAH.)

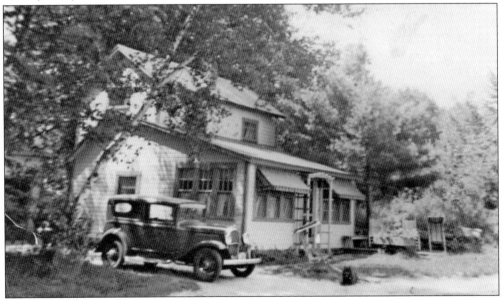

The Sandy Shore Cottages property was originally owned by George A. Emerson, Esq., a Harvard Law School graduate and prominent businessman in Bristol from the 1880s to 1930s. It is rumored that the original one-story building was an icehouse, which was "skated" across the frozen lake during the winter months to its current location. The second story was added in the 1930s.

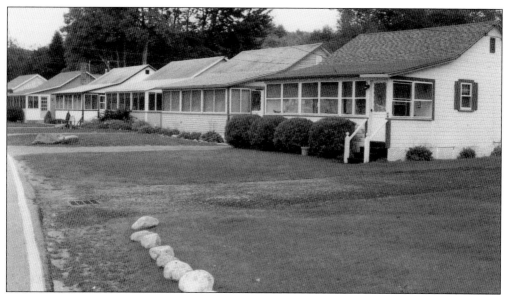

Sandy Shore Cottages was owned and operated by Frank and Charlotte Goodsoe from 1944 to 1965, then owned and operated by John and Margaret "Greta" O'Connor until 1968. It had six rental cottages, which were sold individually in the 1960s for about $5,000 each. These rental cottages were built in the 1940s on about three acres of waterfront property and had over 400 feet of private, sandy beach with docks and rafts.

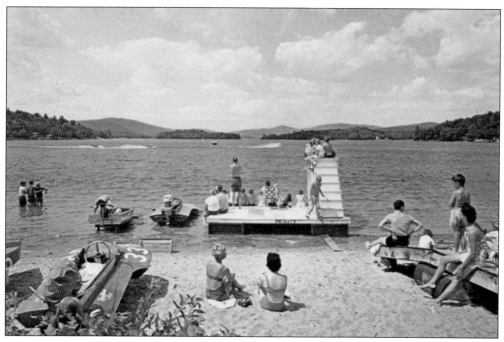

Motorboat races were a popular attraction at the foot of Newfound Lake in the 1950s, as shown here. This image was taken near Lakeview Cottages' private beach, where visitors enjoyed a raft with a slide into the water and water-skiing lessons. However, the Town of Bristol claimed ownership of the beach in the 1990s amid much controversy, which exists to this day.(RSC.)

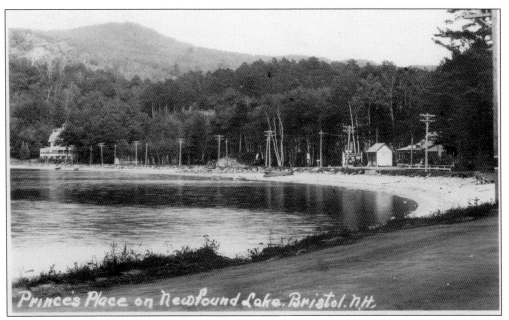

As shown on the cover, this c. 1920s postcard depicts the foot of the lake. Prince's Place is seen in the foreground; Mayfair Lodge, which is now Swissview Condominiums, can be seen to the far left and to the right of what is Darling's real estate office, now the Big Catch Restaurant. In the trees above, readers can catch a glimpse of Cliff Cottages, now the Ledge Water Steak House, which opened in 2011.

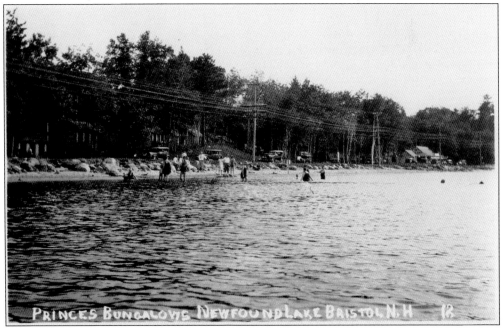

Located on Shore Drive in Bristol at the foot of Newfound Lake, Prince's Place was a famous resort known for its beautiful sandy beach, cozy bungalows, and spectacular lake and mountain views. This amazing lakefront property was purchased by Walter Farr Prince in 1925 and is now the Silver Shores Condominium Association.

25

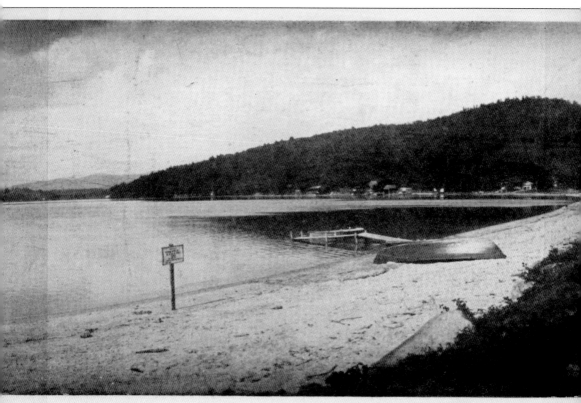

Located on Shore Drive in Bristol, Prince's Bungalows featured 1,050 feet of sandy private beach. This impressive waterfront purchase was reported in the *Bristol Enterprise* in 1925 shortly after Prince bought this unique property. This 1920s postcard shows bathers on the beach at Prince's, a dock, rowboats, and a sign posted on the beach that appears to say, "Private—Prince's

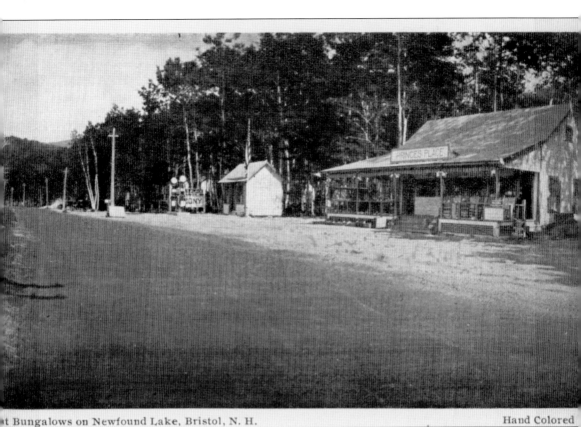

t Bungalows on Newfound Lake, Bristol, N. H. Hand Colored

Beach." Prince's Place general store offered ice cream, cold drinks, postcards, candy, cigarettes, cigars, and other products and was a popular hangout for young and old alike. The Socony gas station provided fuel for the fortunate folks who owned cars in those days, but the gas station was removed in later years.

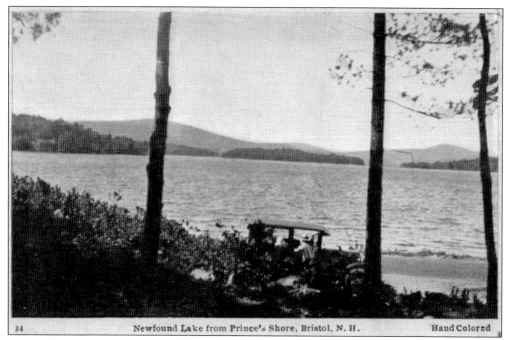

34 Newfound Lake from Prince's Shore, Bristol, N. H. Hand Colored

Pictured here is a vintage automobile parked on "Prince's Shore" around the 1920s. This beach was privately owned until the 1990s when the Town of Bristol claimed ownership after much controversy, and it was renamed Avery-Crouse Beach. The automobiles such as the one depicted here had one major disadvantage in that they could only go uphill in reverse, making traveling in the mountains around Newfound Lake a real challenge.

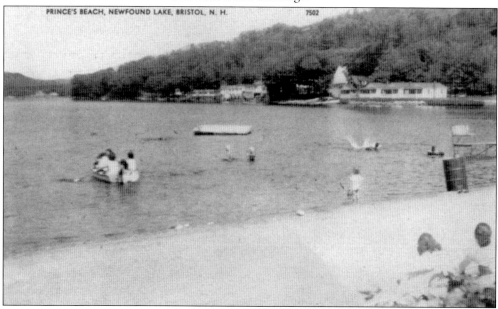

Prince's Beach, located on Shore Drive in Bristol, featured rafts, docks, boating, and swimming on its sandy private beach shown here around the 1930s. It was a famous resort where busloads of well-to-do city folks flocked for the fresh mountain air, pristine waters, and a wide variety of summer activities.

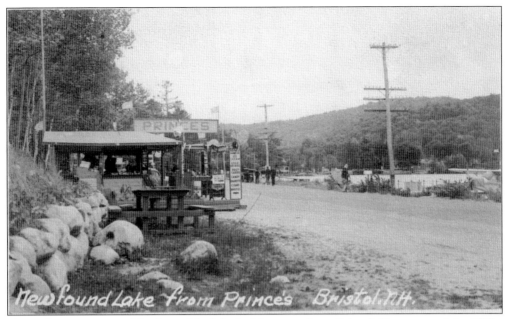

Newfound Lake from Prince's Bristol. N.H.

Shown here is a view of the foot of the lake looking west from Prince's Place around the 1920s. A seaplane is visible on the shore near docks on the waterfront, and two boathouses can be seen on either side of the bridge in the background. The foot of the lake was a popular location offering boatbuilding, steamboats for pleasure cruises, and mail delivery as well as fishing, boating, bathing, and relaxation.

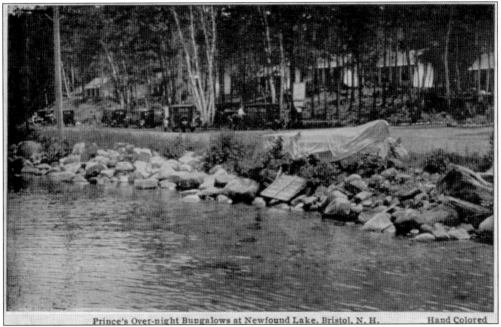

Prince's Over-night Bungalows at Newfound Lake, Bristol, N. H. Hand Colored

This c. 1930s image of the shore of Prince's Beach at the foot of the lake shows canoes stored on the beach for guests. Newfound Lake was originally called Pasquaney, which means "the place where birch bark for canoes is found," by local Indians. The Pemigewasset Indians used canoes here as their main form of transportation until the 1750s when they moved to Canada.

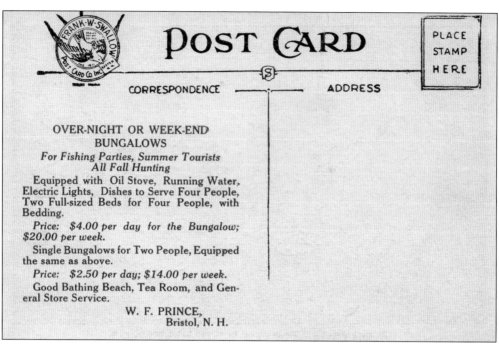

This image lists the amenities offered at Prince's Overnight Bungalows around the 1920s–1940s. It is interesting to compare the $4-per-day rate with the $150 per night commonly charged now around the lake. With its 1,050 feet of sandy shore and majestic mountain views, Prince's Beach was considered one of the lake's finest bathing beaches.

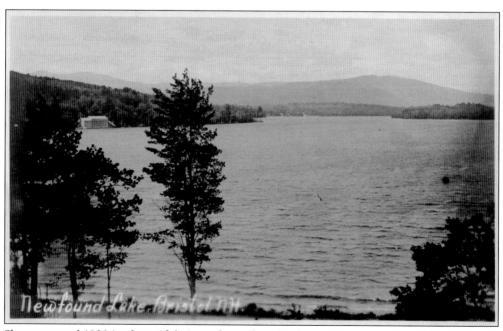

Shown around 1920 is a beautiful view of Newfound Lake looking north from Prince's Beach, now Silver Shores Condominium Association. The icehouse on the western shore was torn down in 1954. It stored 1,000 tons of ice averaging 20 inches in thickness.

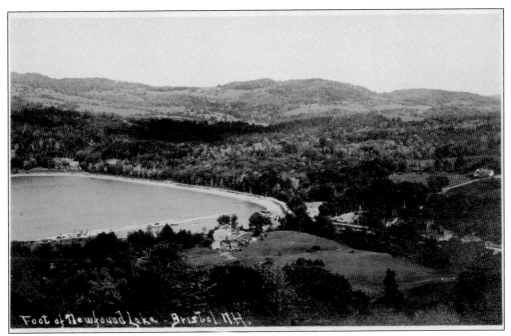

The foot of Newfound Lake is depicted around 1900. Mayfair Lodge is in the southeast corner (left). Salmon screens were in the southwest corner of the lake by the outlet to the Newfound River, which prevented salmon from flowing down the river. A small hatchery existed here after the formation of the Newfound Lake Fish and Game Protective Association in 1908.

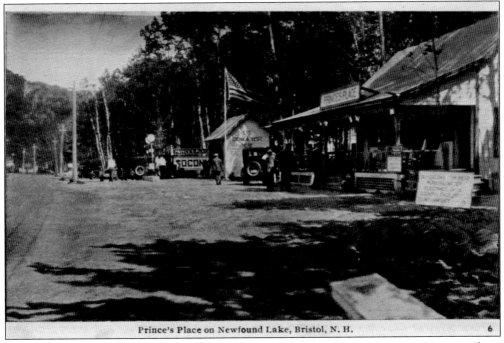

This c. 1930s postcard provides a closer view of Prince's Place on old Route 3A, now Shore Drive, with a Socony gas station, private beach, and overnight bungalows. Owner Walter F. Prince was born on May 9, 1861, and died in Bristol, New Hampshire, on March 2, 1938.

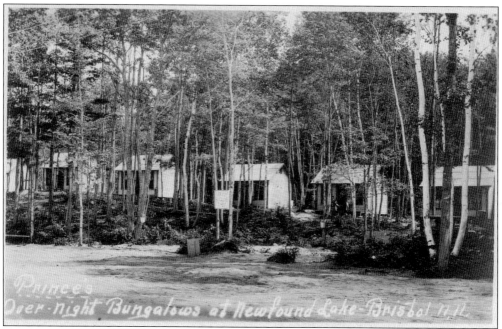

Shown here are the one-room and one-bedroom overnight bungalows at Prince's Place. Walter Prince, the owner, was a former professional baseball player, a first baseman for the Washington Nationals from 1883 to 1884. Prince invested in other waterfront property on Newfound Lake as well, including the waterfront property now known as Camp Berea in Hebron.

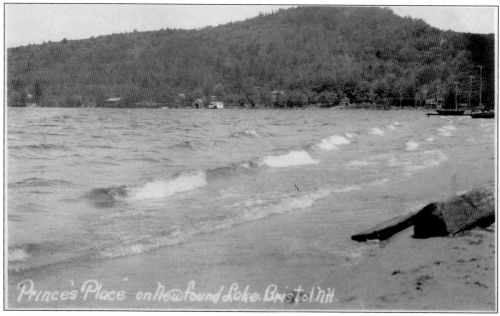

This c. 1920 postcard shows the shore of Prince's Beach and the docks and rowboats along the foot of the lake. Most rowboats were handmade from logs cut at Merrill's sawmill at the foot of the lake; the boats were crafted by LaForrest Ballou, a blacksmith and boatbuilder who lived on the farm by the dam.

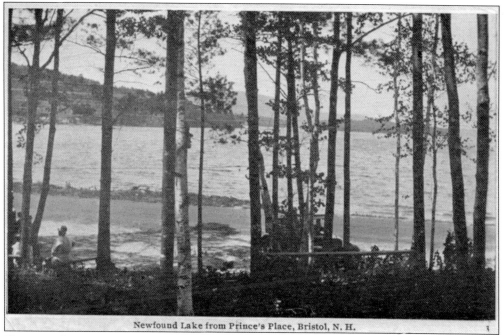

Newfound Lake from Prince's Place, Bristol, N. H.

Shown in the mid-1920s are Prince's Place Beach and retaining wall. A seaplane landed here in 1929 and was front-page news in the *Bristol Enterprise*. The wall was a perfect place to relax and watch the sunset, which is still enjoyed to this day. This postcard is postmarked 1928.

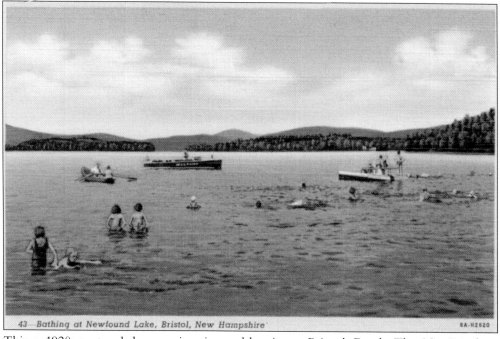

43—Bathing at Newfound Lake, Bristol, New Hampshire

This c. 1920s postcard shows swimming and boating at Prince's Beach. The *Miss Print* boat operated from Prince's dock, offering rides to paying passengers. The raft was an amenity available to all staying at Prince's resort. It is no wonder this was always such a popular place to vacation.

This is a view of Shore Drive, formerly old Route 3A, which was a dirt road leading to Plymouth, New Hampshire. This dirt road was originally part of a 200-acre waterfront parcel owned by Samuel S. Fellows in the early 1800s. In 1864, Fellows sold 150 acres containing this shorefront and road to Giles W. Ordway "excepting and reserving the rights of the public in the highways passing through the described premises." Ordway sold a portion of this property described as a 15-acre "pond lot" to his wife, Betsey. This same 15-acre lot was later sold to David H. Sleeper in 1873 "excepting the rights of flowage previously granted to the Lake Company." This refers to a deed dated 1868 in which Betsey Ordway gave the Lake Company the right to raise and lower the lake between the road and the shore "but no higher" because up until then, this road on her property would be flooded for the sake of waterpower, which made the road impassable. This postcard is postmarked 1910.

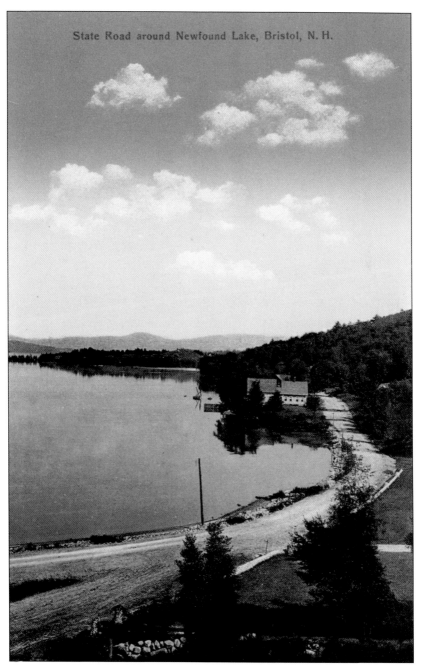

State Road around Newfound Lake, Bristol, N. H.

This c. 1930 image shows the original state road, old Route 3A. The stone wall is at the corner of the old Mayfair Lodge resort (bottom right), now Swissview Condominium Association. In the late 1800s and early 1900s, logs were stored on this beach after being towed across the lake and then sent along the shore to the river for use at the mills along the waterway. The old Route 3A shown here was rebuilt in the 1940s, so this portion of Route 3A on the east shore then became Lakeside Road. Even without the same high volume of traffic after the new Route 3A was finished, the cottage colonies on Lakeside Road flourished, and more summer cottages were built in the 1950s and 1960s to accommodate all of the summer visitors.

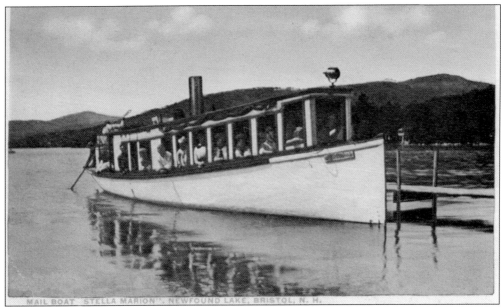

This is the mail boat *Stella Marion* docked at the foot of the lake near what is now the Tracys' cottage on Shore Drive in Bristol. The boat was built by Ambrose Adams and named after his daughters. He delivered mail on Newfound Lake beginning in 1906 and was paid $4 per round-trip. Some residents rowed out to meet the *Stella Marion* to get their mail, while others had mailboxes on buoys and docks.

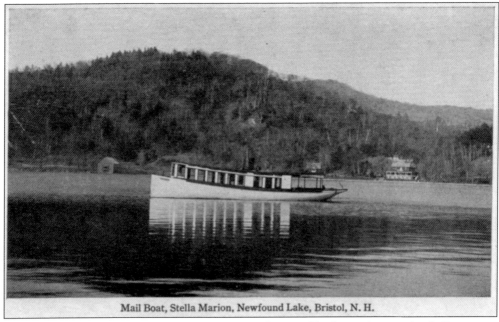

Mail Boat, Stella Marion, Newfound Lake, Bristol, N. H.

On August 27, 1915, the original *Stella Marion* was destroyed by fire on its mooring in Pasquaney Bay. In 1916, Adams built the *Stella Marion II*, with seating capacity for 50 people, and continued to operate until 1921. Capt. Samuel Hentall also ran a commercial boating operation at the foot of the lake from the 1890s through the late 1920s at what is now the Newfound Lake House, formerly called the Landlocked Salmon House.

Three

EAST SHORE

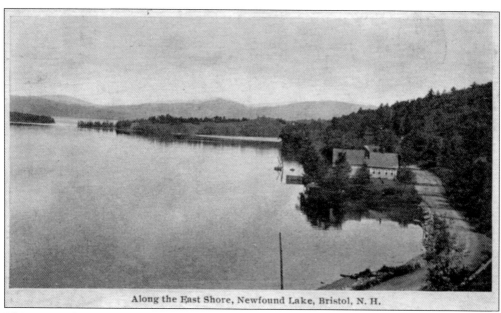

Along the East Shore, Newfound Lake, Bristol, N. H.

This postcard postmarked in 1929 shows old Route 3A around 1910 and Lakeside Cottages on the east shore of Newfound Lake. This was the only highway to Plymouth at the time. Lakeside Cottages was a summer resort with private beach, boating, and cabins and is now a condominium association of individual cottages.

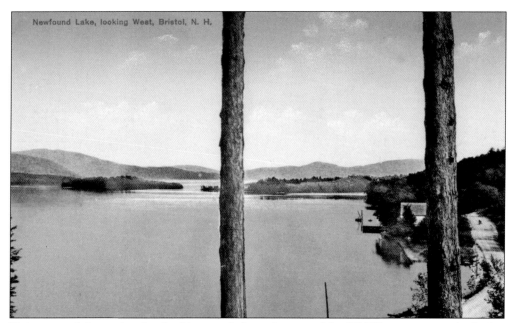

This postcard shows the view looking north from the area of the Cliff Cottages, now the Ledge Water Steak House, around 1910. Mayhew Island is visible to the northwest next to Pike's Point (right), and Tenney Mountain and Crosby Mountain are in the background. This view still looks remarkably the same from this vantage point to this day.

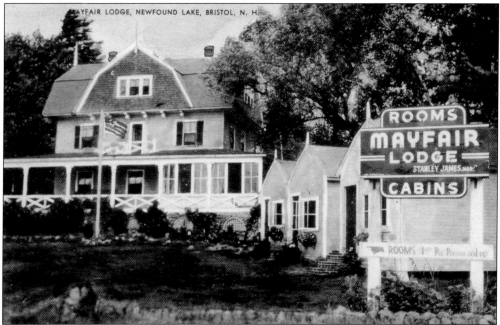

Mayfair Lodge (now Swissview Condominiums), located on Mayhew Turnpike in Bristol, is seen here around the 1940s. Mayfair Lodge had a private beach, dock, and rooms for rent. In 2007, Swissview proved ownership of its beach after the Town of Bristol mistakenly claimed it. Swissview's land extends into the lake to about eight feet deep because the dam built in 1858 flooded the original shoreline and raised the lake by that height.

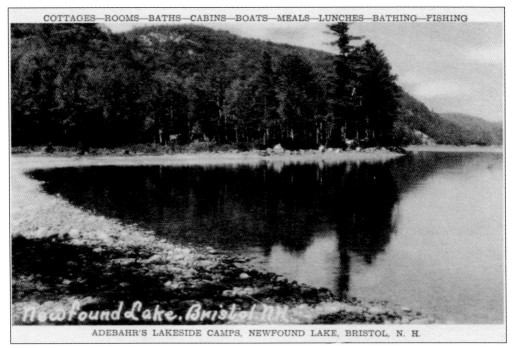

Newfound Lake, Bristol, N.H.

ADEBAHR'S LAKESIDE CAMPS, NEWFOUND LAKE, BRISTOL, N. H.

This postcard is of the view from Adebahr's Lakeside Camps on old Route 3A, now Lakeside Road, in Bristol. It had a Socony gas station, boats, docks, and rental cottages. The gas station is long gone, but the condominium association enjoys the other amenities to this day.

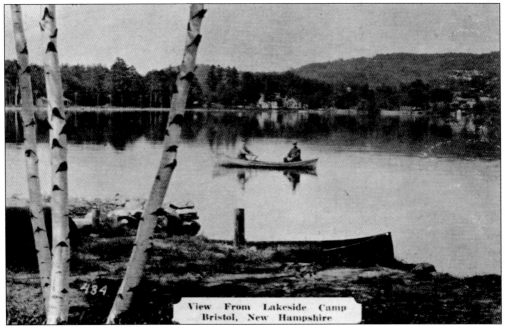

View From Lakeside Camp
Bristol, New Hampshire

This c. 1910s scene from Lakeside Camp on what is now Lakeside Road shows a view toward the southwest corner of the lake. The Landlocked Salmon House by the outlet to the Newfound River, now known as the Newfound Lake House Condominium Association, is shown in the distance, with boathouses to the left and right of the bridge.

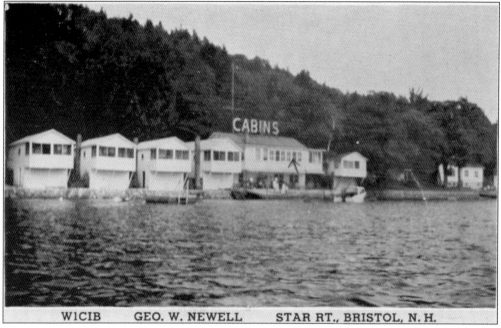

WICIB GEO. W. NEWELL STAR RT., BRISTOL, N. H.

This postcard shows another cottage colony on the southeast shore of Newfound Lake located on Lakeside Road (formerly old Route 3A) in Bristol around the 1920s. These cabins still exist and look almost identical to this day, but they are now individually owned. They still enjoy a private beach, dock, and moorings in a wonderful lakefront setting.

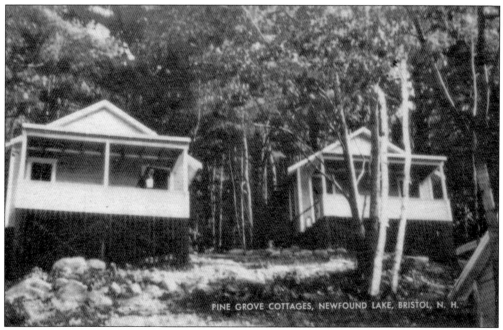

PINE GROVE COTTAGES, NEWFOUND LAKE, BRISTOL, N. H.

Pine Grove Cottages was a popular cottage colony located on the old Route 3A (now Lakeside Road) in Bristol. The cottages offered "large camps with heat and private toilet, gas and shuffleboard," as described on this postcard.

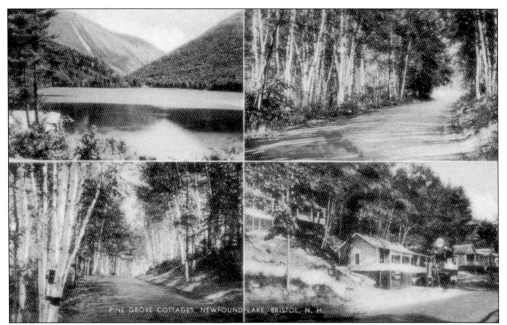

The Pine Grove Cottages (now Pine Grove Condominium Association), located on Lakeside Road in Bristol, offered overnight cottages, a private beach, dock, boating, swimming, fishing, snack bar, gas, and shuffleboard. This multi-view postcard is from about 1930. This cottage colony remains relatively unchanged in appearance, and those staying here still enjoy most of the original amenities, except the gas station and snack bar.

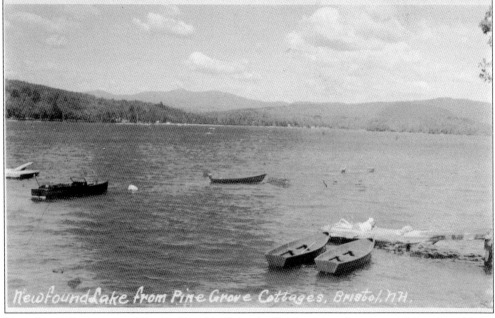

Pine Grove Cottages on Lakeside Road in Bristol offered spectacular views of Newfound Lake from a private beach, as seen here. This view is looking northwest and shows a dock, raft, and boats, with Mount Cardigan in Alexandria in the background to the left. West Shore Road is on the opposite shore.

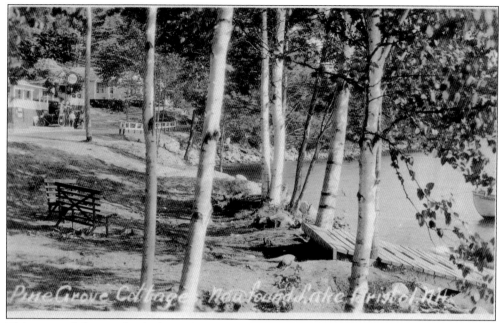

This postcard depicts the dock and beach area of Pine Grove Cottages on the eastern shore of Newfound Lake. The gas station and snack bar shown to the left around 1930 are no longer in existence. The boat offshore appears to be named *Halcyon*, and there is an automobile parked at the gas station.

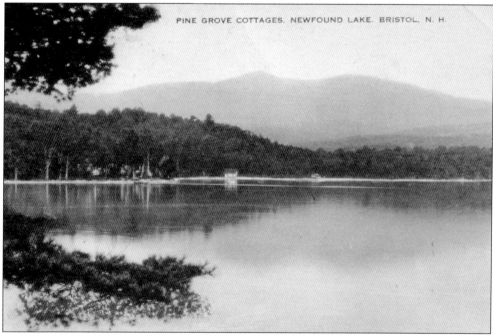

This is another sweeping view of Newfound Lake looking northwest from Pine Grove Cottages around the 1920s. West Shore Road is seen in the distance with just a few waterfront buildings in existence at that time. This view along the shoreline has changed considerably over the years, with a multitude of cottages, homes, and year-round condominiums now.

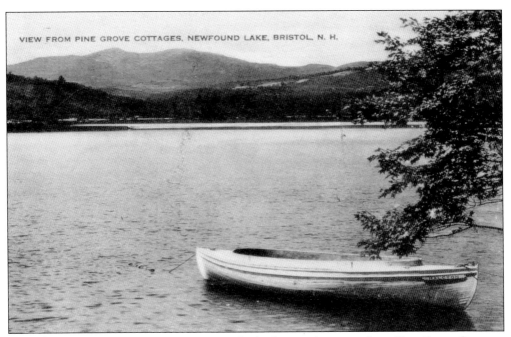

VIEW FROM PINE GROVE COTTAGES, NEWFOUND LAKE, BRISTOL, N. H.

This postcard features Mount Cardigan in the background, as seen from Pine Grove Cottages on the southeast shore of Newfound Lake in Bristol. Most boats from the 1920s were locally handcrafted rowboats and canoes typical of the one named *Halcyon* shown in this postcard. Today, rowboats and canoes are still popular, but these boaters must be extra careful of all of the speedboats and jet skis buzzing by nowadays.

Published by D. M. Calley From H. O. Pike's, Newfound Lake, Bristol, N. H.

This postcard postmarked 1912 shows the unspoiled landscape of Newfound Lake from Pike's Point on the lake's southeast shore. Much of this scenic view remains the same today, but there are obviously more waterfront homes and cottages along the shore.

43

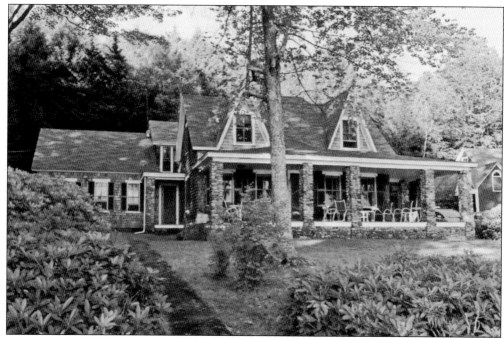

The Emerson cottage, located on Whittemore Point in Bridgewater, was built in 1889 by George A. Emerson, Esq., (known as the "Squire") and remains in the Emerson family to this day. The Emerson family celebrated their cottage's 100th anniversary in 1989. (RHE.)

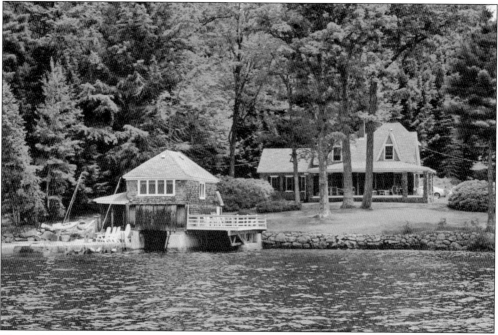

The c. 1889 Emerson cottage and boathouse on Whittemore Point in Bridgewater are remarkably unchanged from their original days as a summer farm. While the barn is still standing, there is no longer livestock in it. The boathouse originally had a windmill on the roof, which pumped water uphill to a holding tank for the house, orchards, and gardens. (RHE.)

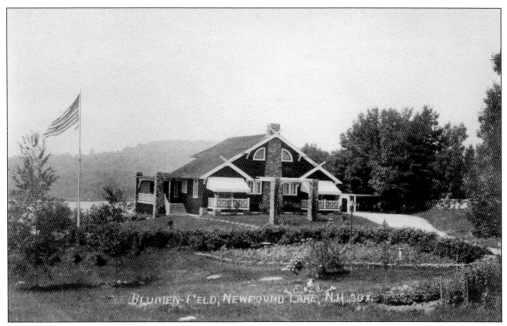

This property is located on Poole Hill Road in Bridgewater. Although not waterfront, it sits very high on a hill with views of Newfound Lake from the front and Squam Lake in Holderness from the side. This was originally a summerhouse called Blumen-Feld built for a very fortunate family from Plymouth, New Hampshire.

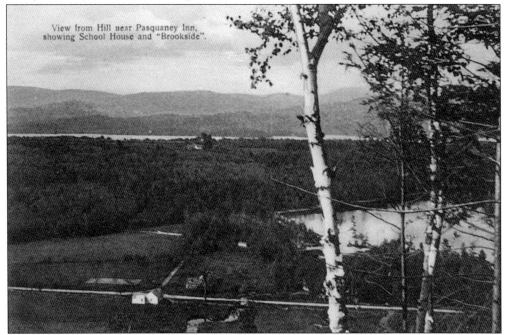

Taken from the east shore, this postcard image looks west from the hill over the Pasquaney Inn on Mayhew Turnpike in Bridgewater and shows a schoolhouse and Brookside Cottages on Pasquaney Bay in the early 1900s. This area has changed dramatically since then, and there are now many wonderful waterfront homes and cottages all around Whittemore Point.

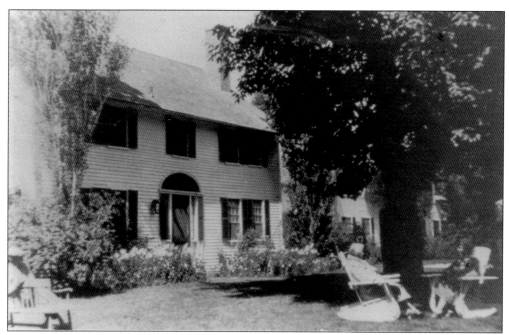

Wagon Wheel Inn (now Wagon Wheel Condominium Association), located on Mayhew Turnpike in Bridgewater, is shown in the 1960s. In addition to lakeside lodging, it had a popular restaurant and lounge owned and operated by the Zareas family and located in the main building, with entertainment on the weekends. (BHS.)

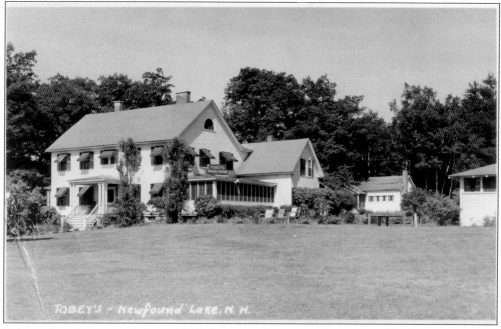

Tobey's, later known as Whip-O-Will Inn and Cottages, is located on Mayhew Turnpike in Bridgewater on the eastern shore of Newfound Lake. This property is now home to the Whip-O-Will Condominiums, which were built in 1985. Tobey's was a popular summer resort, with Tobey's Dining Room and rooms and cottages for rent and a beautiful private beach area.

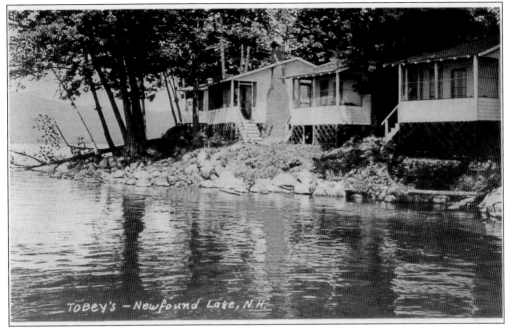

Tobey's Cottages was located on the east shore of Newfound Lake in Bridgewater, shown here in the early 1900s. The quaint New England–style cabins shown in this vintage postcard image were typical of summer lodging in the early 1900s, which were built as close to the lake as possible.

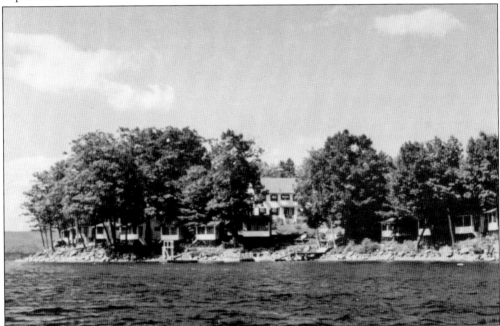

Whip-O-Will Cottages, formerly known as Tobey's Cottages, was located on Whittemore Point in Bridgewater and offered lakefront lodging for rent in the early 1900s. A motel was added later to accommodate its thriving summer vacation business on Newfound Lake. This picturesque setting near Pasquaney Bay still draws visitors back year after year.

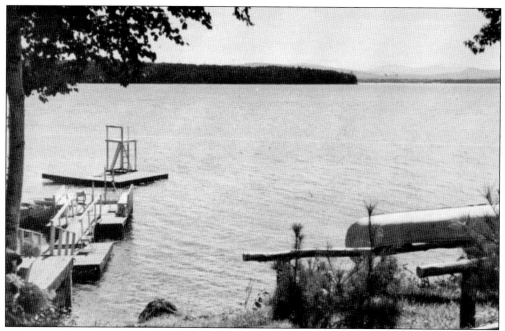

Tobey's Cottages, located on Pasquaney Bay in Bridgewater, enjoyed a beautiful, extensive private beach with docks, boats, and rafts. This c. 1920s postcard image shows Newfound Lake before rapid development took place on the opposite shore. Of note is the rustic, handmade canoe rack (right) next to the shore.

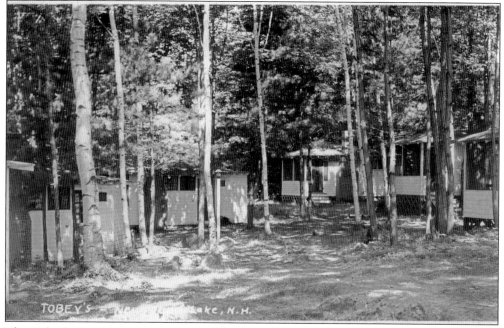

The Tobey's Cottages property was sold in the 1980s to clear the land for Whip-O-Will Condominiums. These charming cottages were nestled in a wooded setting on Pasquaney Bay in Bridgewater. They were obviously built with comfort in mind and included screened porches for relaxing summer nights.

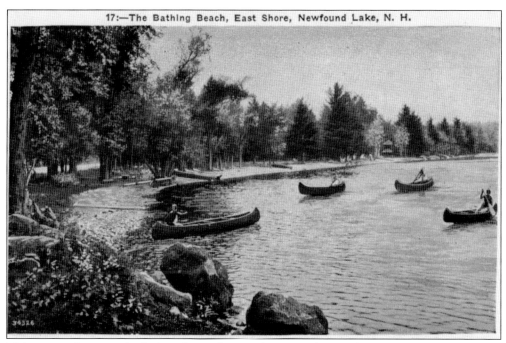

This postcard postmarked 1931 shows the "Bathing Beach" on the east shore of Newfound Lake. This image shows a boathouse or canoe rack on the shore, with canoes and boats stored on the beach. These early boaters must have thoroughly enjoyed the exquisite serenity of Newfound Lake in those early days.

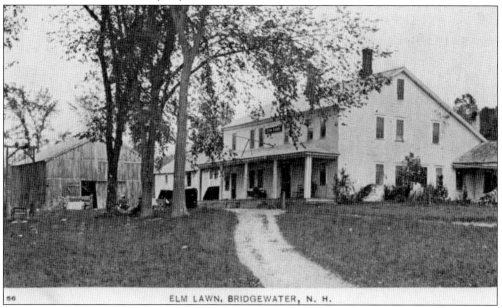

ELM LAWN, BRIDGEWATER, N. H.

Located on Route 3A in Bridgewater, Elm Lawn was built about 1800 by Peter Sanborn after hearing that the new Mayhew Turnpike was being constructed. A.P. Hoyt was the landlord, and Hoyt's Tavern, as it was called at that time, was a well-known place. Later renamed Elm Lawn because of its beautiful elm trees, it was a popular summer resort. This postcard is postmarked 1910.

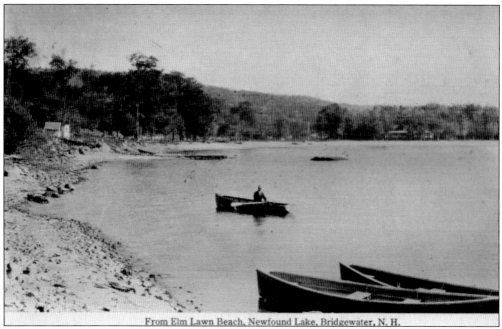

From Elm Lawn Beach, Newfound Lake, Bridgewater, N. H.

Elm Lawn offered bathing, boating, and fishing on its large private beach. Rowboats and canoes were the main crafts for boating, and most were handmade by local boatbuilders using trees from the area. This postcard is postmarked 1918.

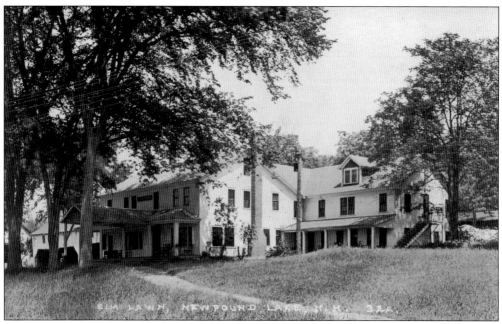

Elm Lawn is depicted here with building expansion and additional rooms on the right side of the main structure to accommodate the growing number of tourists looking for a quiet, charming getaway at Newfound Lake. This wonderful resort is no longer standing.

Four

NORTH SHORE
(HEAD OF THE LAKE)

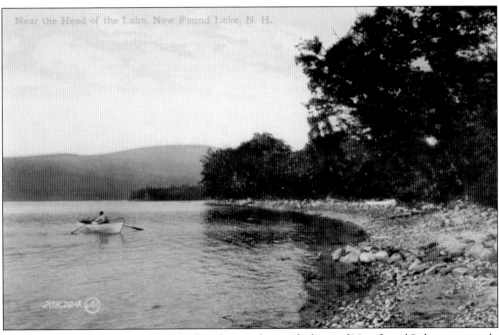

Near the Head of the Lake, New Found Lake, N. H.

This 1920s postcard shows the rocky beach near the north shore of Newfound Lake, commonly referred to as the "head of the lake" or the "north end" and located in the town of Hebron. Even to this day, the north shore of the lake is much less populated than the southern shore area. The sparser population of the north shore has been attributed to visionaries making significant conservation efforts dating back to the early 1900s.

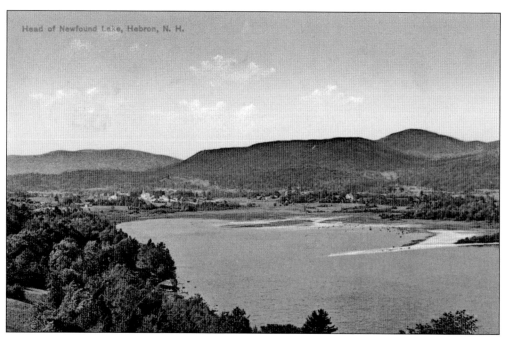

Head of Newfound Lake, Hebron, N. H.

Paradise Point Nature Center and Sanctuary is located on North Shore Road in Hebron, with 43 acres of woodlands, marshlands, and hiking trails and 3,500 feet of lakeshore, which was donated by Col. and Mrs. Alcott Elwell in the 1960s. This postcard shows the head of Newfound Lake around 1915. This nature lover's paradise has been well preserved and is open year-round. For more information, readers can visit www.nhaudubon.org/locations/centers/newfound.

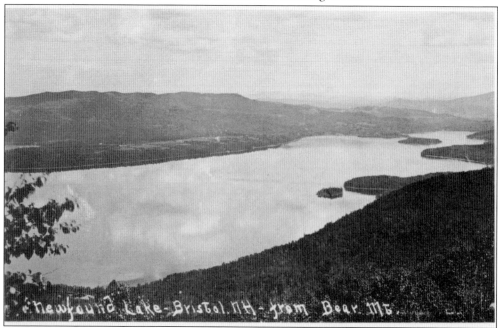

This view of Newfound Lake was taken looking south from Bear Mountain. Cliff and Belle Islands are shown on the right, and Mayhew Island is visible in the distance. Mayhew Turnpike can be seen on the opposite shore.

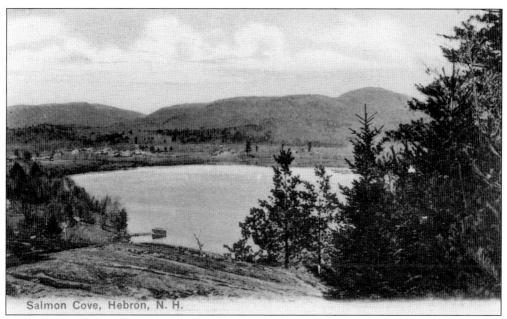

Salmon Cove, Hebron, N. H.

Salmon Cove is located in Hebron on Newfound Lake. The cove was a popular fishing spot, which was known for an abundance of landlocked salmon, lake trout, black bass, pickerel, chub, and perch. It is easy to see why fishermen have always been drawn to this beautiful crystal clear lake, and there are many other favorite fishing spots around the lake as well.

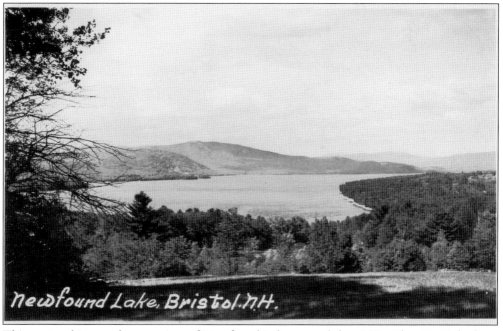

Newfound Lake, Bristol, N.H.

This postcard image shows a view of Newfound Lake around the 1920s. The view is looking south from Hebron at the head of the lake and clearly shows how sparsely populated the area was back in those days. North Shore Road is in the foreground and has changed considerably since then.

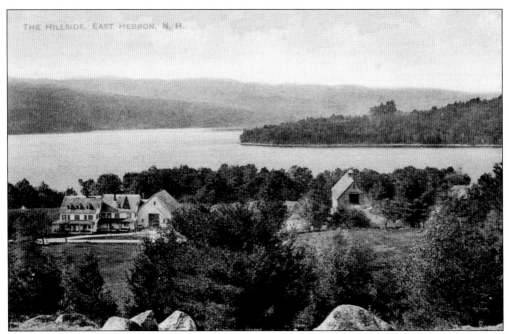

The Hillside Inn (now known as Hillside Condominium Association), located in East Hebron, is shown here. The inn, including 80 acres, was purchased by Mr. and Mrs. George Smith around 1881 for $2,100 as a fixer-upper. The old farmhouse and building were about 100 years old at that time and showing their age.

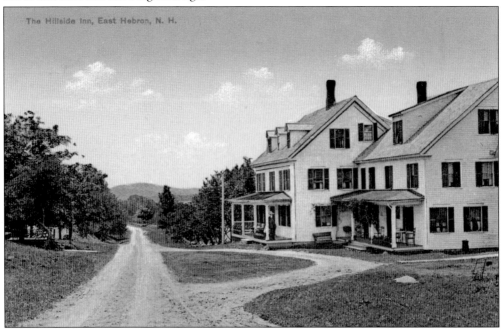

This postcard is a close-up view of the Hillside Inn on Mayhew Turnpike in Hebron around 1900. Mr. and Mrs. George Smith opened the inn as a boardinghouse for hunters and fishermen in 1882. A second story was added in 1884 thanks to its popularity. The inn was updated in the 1890s to accommodate parents of children staying at Camp Pasquaney.

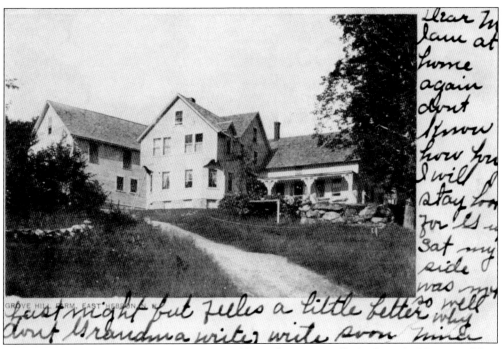

This postcard shows Grove Hill Farm. It is addressed to Mrs. Belle Sanborn in Newport, New Hampshire, from Nina and postmarked 1908. Grove Hill Farm was owned and operated by Mr. and Mrs. John W. Sanborn and located at the head of the lake in Hebron.

Grove Hill Farm was host to avid fishermen, as seen in this 1890s postcard. In 1891, the weekly journal *Forest and Stream* reported that 50 fishermen stayed at Grove Hill Farm that season and "all agreed that as a fishing resort, Newfound Lake has no equal in New England."

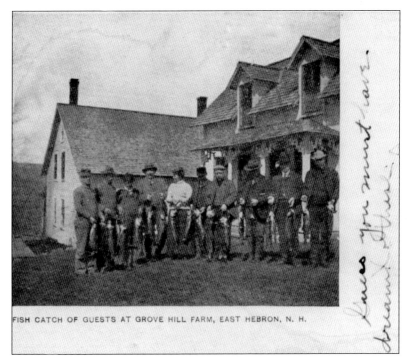

FISH CATCH OF GUESTS AT GROVE HILL FARM, EAST HEBRON, N. H.

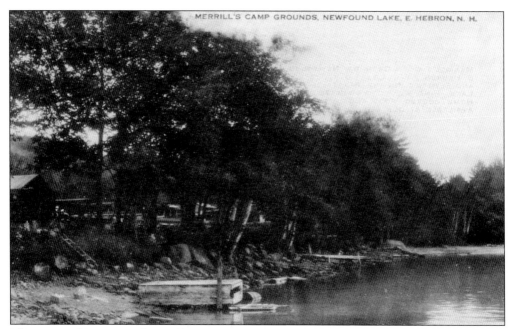

This postcard is a view of Merrill's Camp Grounds in East Hebron around 1920. Merrill's was advertised as "the finest camping grounds on the lake" with "home cooked food and camping supplies available at our store."

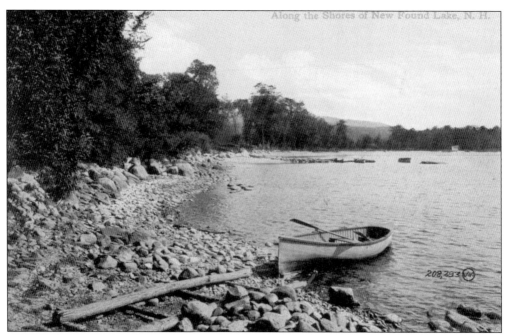

This c. 1920 view is of one of the handmade canoes used for fishing and relaxing on the shores of Newfound Lake. Of note is the handcrafted, rustic canoe rack on the shore. This image was originally thought to be taken along the shores at the head of the lake but is possibly along the east shore near Pasquaney Inn.

Five

WEST SHORE

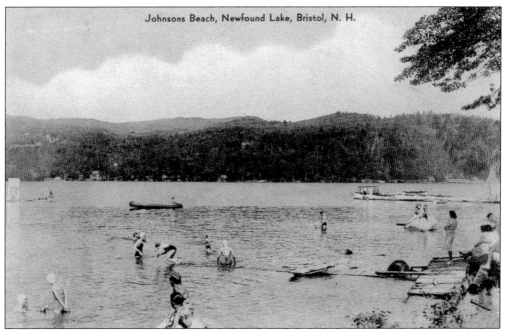

Johnsons Beach, Newfound Lake, Bristol, N. H.

This postcard depicts Johnson's Beach on West Shore Road in Bristol. It is postmarked 1942. Arthur "Pat" Johnson had a boat livery on Pasquaney Bay in Bridgewater, but when his partnership with a Mr. Corburn dissolved in the 1930s, he moved the boathouse across the lake during winter to this location, where he took out fishing groups, rented boats, and delivered mail and supplies to Groton School Camp on Mayhew Island.

Showing West Shore Road, this postcard is postmarked November 8, 1910, and signed by George A. Emerson, Esq., a well-known businessman and Harvard Law School graduate who invested in numerous waterfront lots around the lake as well as buildings in Central Square in downtown Bristol. This image shows the unspoiled natural beauty of Newfound Lake in the early 1900s. Much of the growth and development of the towns around Newfound Lake are attributed to the vision of prominent businessmen from Boston, Massachusetts, such as Emerson. Instrumental in bringing electric lighting to this area, he formed Bristol Electric Light Company in 1889 with initial capital of $8,000 and served as a director and treasurer from the 1880s through the early 1900s. Emerson was also the Bristol treasurer and a Bristol selectman for several years.

The reverse side of this postcard sent by George A. Emerson, Esq., is shown here. This card was mailed during the same period that Emerson owned the property at the foot of the lake now owned by the authors' family, so it has extra meaning attached to it in that regard.

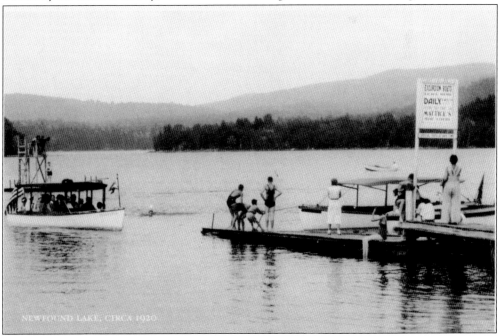

Located on West Shore Road in Bristol near Bungalo Village, Mattice's Boat Livery offered boat rides, fishing, boats for rent, and swimming. This c. 1930s scene shows swimmers as well as boaters dressed up with fancy hats and gentlemen in suits and ties—much different than the beachwear of today. According to the sign, round-trip boat excursions cost 50¢ each.

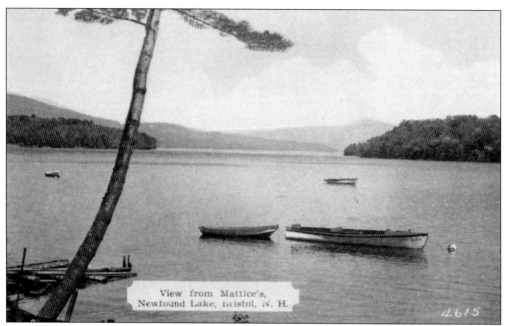

View from Mattice's,
Newfound Lake, Bristol, N. H.

2615

This c. 1930s view from Mattice's Boat Livery on West Shore Road in Bristol has not changed much since then. Mayhew Island is seen to the right with Crosby Mountain in the background. This location now has considerably more boats and moorings, but the view is still as picturesque as ever.

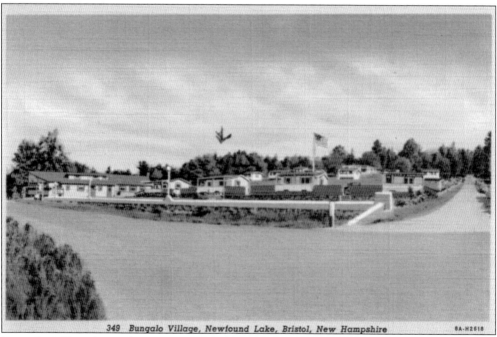

349 Bungalo Village, Newfound Lake, Bristol, New Hampshire 8A-H2618

Bungalo Village, located on West Shore Road in Bristol, is now known as Newfound Sands Condominium Association. This cottage colony was built by W.F. Darling, whose brochure reads, "The air is filled with the balsam firs which heal, soothe and restore the lungs and renew the blood, tones the nervous system and strengthens the muscles."

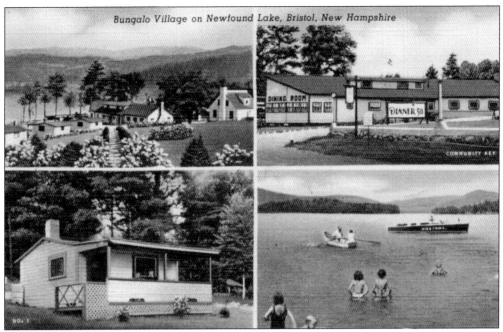

Bungalo Village, now Newfound Sands Condominiums Association, was built in the 1920s and consisted of 38 bungalows set high on a hill with a large private beach and sweeping views of Newfound Lake. This multi-view postcard is postmarked 1946 and shows the Community Key Dining Room, the expansive property, a charming bungalow, and the magnificent private beach.

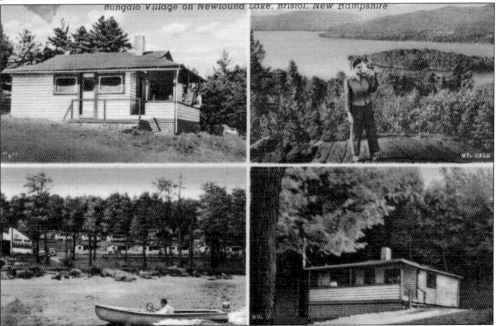

Bungalo Village (Newfound Sands Condominiums) has provided over 80 years of summer fun and relaxation at Newfound Lake. It was originally touted as the "Miami of New Hampshire," offering rooms, camps, cabins, cottages, bungalows, and tents to let on the west shore.

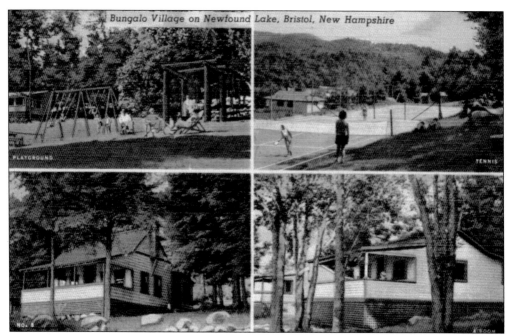

This postcard says, "Bungalo Village, on Newfound Lake, has thirty-eight cozy, well-equipped bungalos including Community Key dining room with recreation hall and store. Bathing, boating, fishing, tennis, shuffleboard, and other outdoor sports are featured." This c. 1940s multi-view postcard depicts the playground, tennis, and bungalows Nos. 8 and 4.

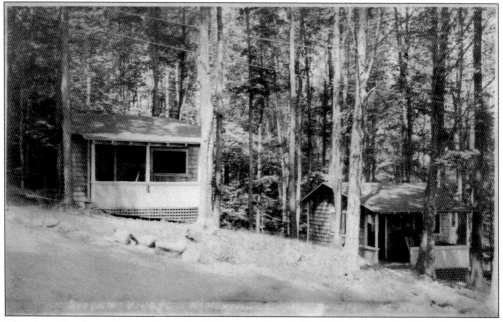

The charming bungalows at Bungalo Village provided affordable summer lodging for visitors. Bungalo Village also allowed visitors to erect tents by the shore of its private beach for a small fee. Many of these bungalows, although individually owned now, still look the same. This postcard is postmarked 1943.

This postcard shows the spectacular view from Bungalo Village's private beach area, which once offered rafts, floats, canoes, rowboats, powerboats, and shady groves. It is now known as Cummings Beach, the Town of Bristol's public beach area.

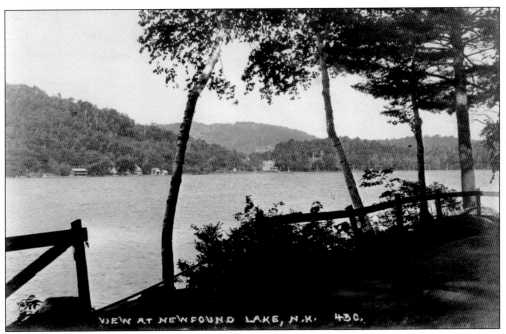

Shown around 1930 is the southeastern shore of Newfound Lake as seen from the beach at Bungalo Village on West Shore Road in Bristol. Mayfair Lodge, now Swissview Condominiums, is in the distance, and a glimpse of Cliff Cottages can be seen through the treetops to the right of Mayfair Lodge.

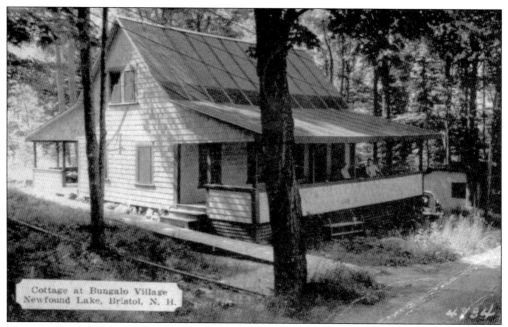

This postcard, postmarked 1940, shows one of the largest cottages at Bungalo Village on West Shore Road in Bristol. Most of the bungalows consisted of one room and one bathroom along with a covered front porch, but this cottage has at least three bedrooms and an extra-large covered front porch overlooking Newfound Lake.

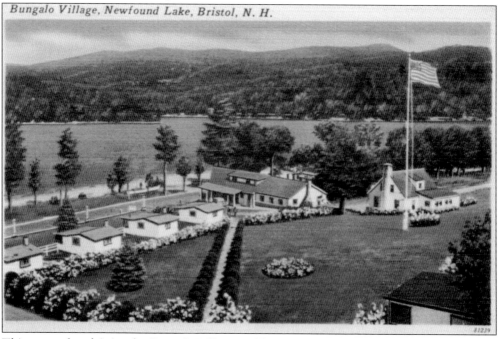

This postcard explaining that Bungalo Village could not accommodate the requested date for a stay was sent to prospective guests in 1950 by Kay Nelson. The grounds were impeccably landscaped and maintained, giving guests a sense of added beauty in an already gorgeous setting.

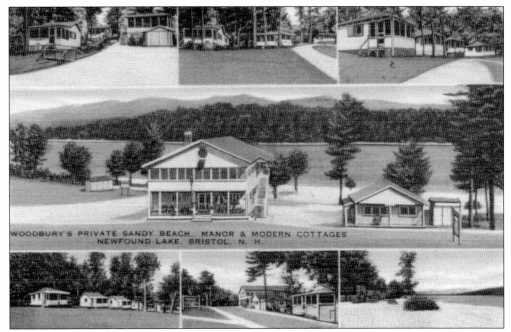

Woodbury's Manor, located just north of Bungalo Village on West Shore Road in Bristol, was a famous resort built by Dr. Linwood Woodbury offering rooms, cottages, meals, a private beach, boating, swimming, and fishing. A lakeside pavilion was added that offered music and dancing every weekend during summer. This postcard is postmarked 1955.

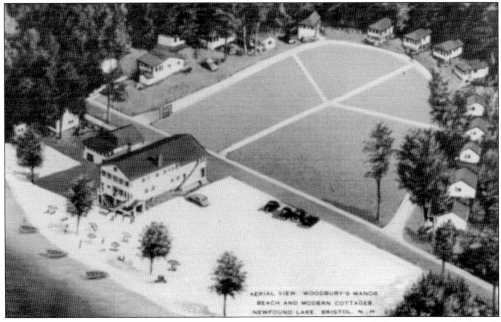

This postcard says, "At Woodbury's only, you get the atmosphere of the country, the beach and the mountains, a rare combination indeed." This property is now known as Manor Estates Condominium Association, and these charming buildings are no longer standing.

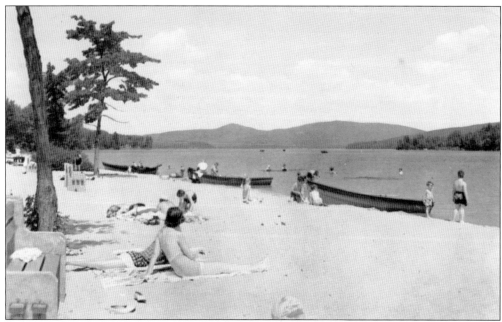

Woodbury's Manor and Cottages, now Manor Estates Condominiums, had a private beach on the west shore that was one of the finest beaches on Newfound Lake. This c. 1940s image shows people of all ages swimming, sunbathing, and boating on a glorious summer day.

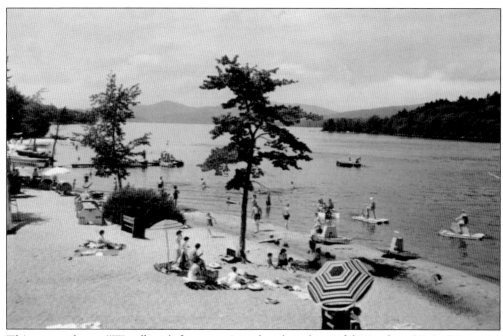

This postcard says, "Woodbury's famous private beach on beautiful Newfound Lake." It is easy to see why Woodbury's was the place to be in summer—with paddleboats, picnic benches, boating, and a beautiful sandy beach.

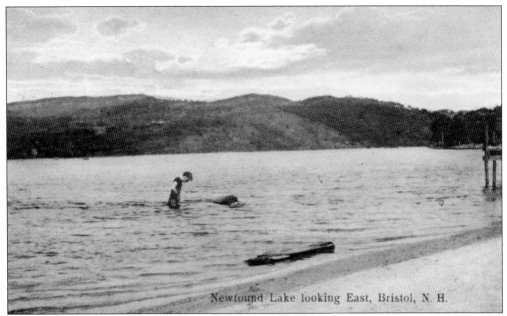

Newfound Lake looking East, Bristol, N. H.

This is another view of Newfound Lake looking east from the west shore in Bristol. This postcard postmarked 1912 shows a young boy and his dog enjoying a nice day at the beach. The dock on the right shows how low the lake used to recede at the end of each summer before a very high dock was built in the 1990s at Wellington State Park for public use that apparently necessitated a higher water level since.

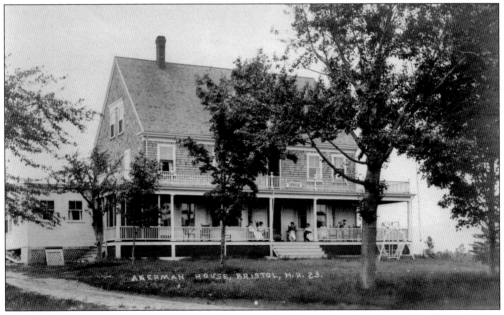

AKERMAN HOUSE BRISTOL, N.H. 23.

The Akerman House was located on the west side of Newfound Lake and built in 1910 as a small business catering to summer visitors. In the spring, it housed large fishing parties of mostly bankers and businessmen from Boston. Summer guests were typically families with children, and fall would be mostly older leaf peepers. Sadly, the Akerman House was destroyed by fire in December 1981.

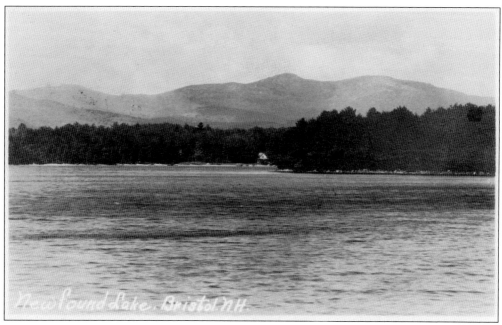

This view is looking toward the west shore of Newfound Lake around 1920. Mount Cardigan is seen in the background, and the shorefront property appears to be mainly undeveloped, except for a large cottage or boardinghouse in the distance with what appear to be several boats near the shore.

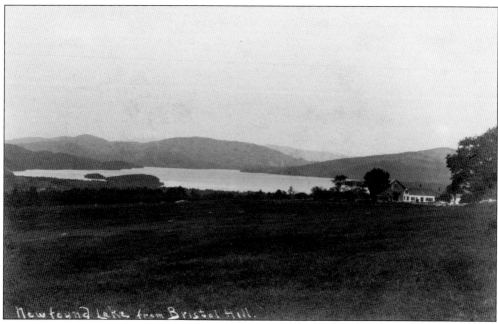

This postcard says, "Shore is part of mother's farm," and is signed by H.H.C. This is the Tunnecliff place on Hemphill Road, now owned by Dr. Carl Carlson. The barn was built by Jonathan Tilton, the great barn-builder of his day. This postcard is postmarked 1911.

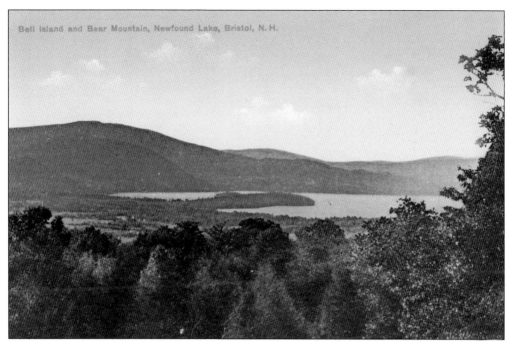

This panoramic view of Newfound Lake shows Belle Island in the foreground near Wellington State Park, with Bear and Sugarloaf Mountains in the background on the west side of Newfound Lake. This postcard image was made in Germany and published by Fowler's Drugstore in Bristol in the early 1900s.

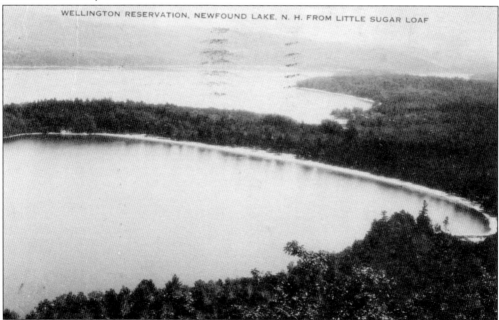

Located at 650 West Shore Road in Bristol, Wellington Reservation contains about 200 acres. This property was purchased by the State of New Hampshire for $1 in 1931 from Elizabeth R. Wellington, a generous summer visitor from New York. For more information, readers can visit www.nhstateparks.com/wellington.html. This postcard is postmarked 1937.

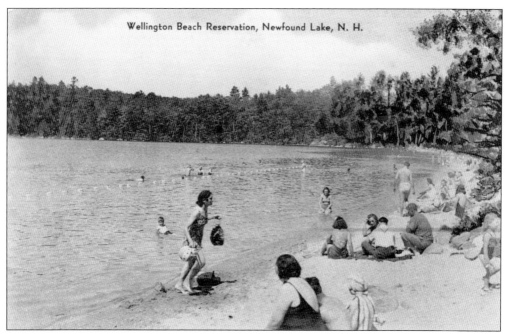

Wellington Beach Reservation, Newfound Lake, N. H.

Wellington Beach Reservation provides a public boat launch, picnic areas, a sandy beach, swimming, fishing, and hiking. It is the largest freshwater swimming beach in New Hampshire. This postcard is postmarked 1940 and depicts families and people of all ages soaking up the sun, swimming, and enjoying a beautiful day of summer fun at this public beach.

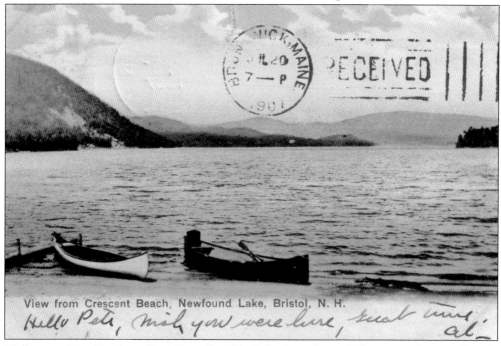

View from Crescent Beach, Newfound Lake, Bristol, N. H.

Wellington State Beach on West Shore Road in Bristol was formerly known as Crescent Beach, no doubt because of its crescent shape. This postcard is postmarked 1907 and shows Sugarloaf Mountain on West Shore Road to the west.

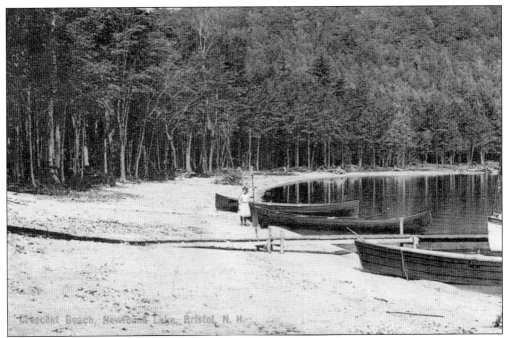

Wellington State Park consists of Wellington State Beach, Belle Island, and Cliff Island. The islands are available to groups, such as Boy Scouts, for summer camping. The Civilian Conservation Corps (CCC), created by Pres. Franklin Roosevelt, did extensive work here in the 1930s to create the picnic areas and original buildings. This postcard is postmarked 1909.

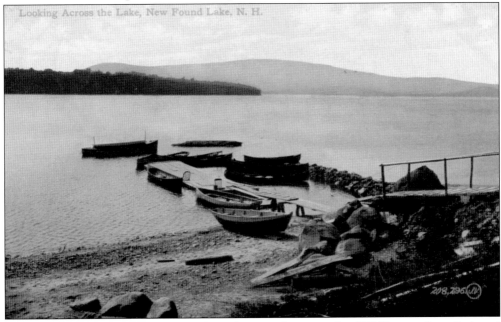

This panoramic beach scene is located on the west shore, south of Wellington State Park and near what is today known as the "Shallows." With its proximity to the free public boat launch at Wellington State Beach, this area is especially popular with day boaters. This postcard is postmarked 1911.

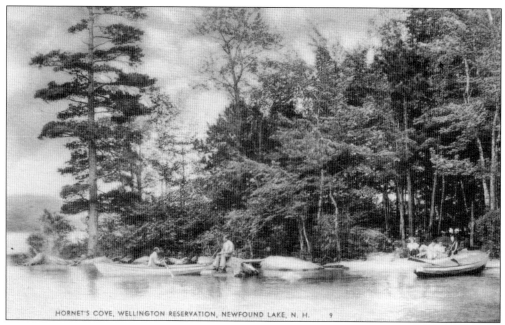

HORNET'S COVE, WELLINGTON RESERVATION, NEWFOUND LAKE, N. H. 9

Shown around the 1930s is what was known as Hornets Cove at Wellington Reservation on Newfound Lake. One can surmise that this cove was named for a proliferation of hornets in the area. Despite its ominous name, it has never ceased to be a popular location to fish, hike, and explore.

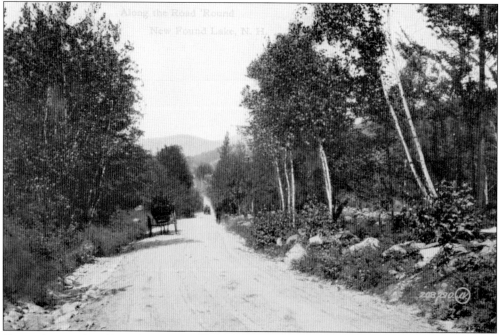

Shown here is the old road around Newfound Lake with a horse and buggy ambling down the dirt highway. This image appears to be West Shore Road heading from Bristol toward Hebron. This road is still heavily wooded and picturesque, especially during the fall foliage season, but now has many beautiful homes, summer camps, and cottages situated along it.

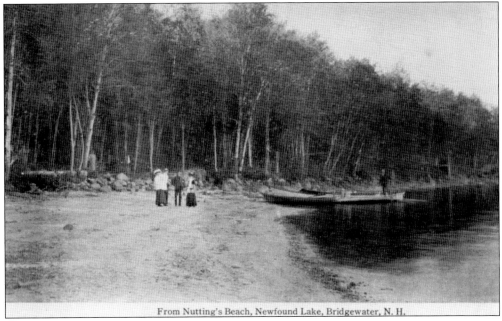

From Nutting's Beach, Newfound Lake, Bridgewater, N. H.

Located on West Shore Road in Bristol and shown here around 1900, Nuttings Beach was a very popular beach area at Newfound Lake, with a spectacular view of the lake and mountains. This postcard says Nuttings Beach is located in Bridgewater, but it is actually found in Bristol near the Hebron town line and Nuttings Brook.

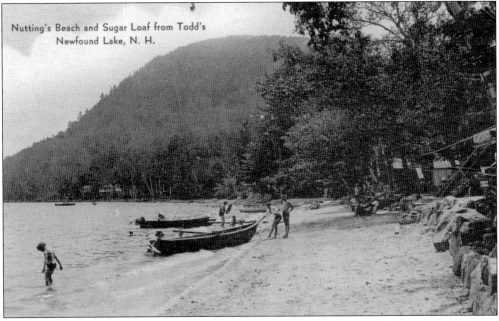

Nutting's Beach and Sugar Loaf from Todd's Newfound Lake, N. H.

Nuttings Beach is located just north of Wellington State Beach on West Shore Road in Bristol. This postcard is postmarked 1946. Nuttings Campground nearby was quite the gathering place in the 1960s and 1970s. This beach is still as beautiful as ever and a very popular place for summer fun, with many modern condominiums, year-round homes, and lakeside cottages along the shore now.

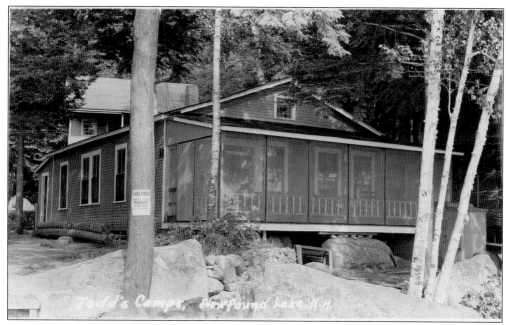

Named for William M. Todd, Todd's Camps was located on the west shore near Nuttings Brook and enjoyed a large private beach in a thickly wooded setting. This c. 1930 view shows a large summer home with an expansive screened-in porch set atop large boulders nestled amid the trees.

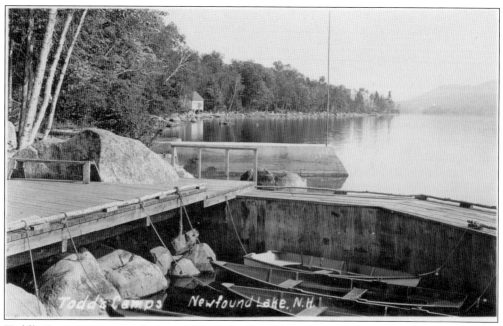

Todd's Camps was a popular vacation spot in the 1920s. Shown here is its boat basin. George A. Emerson, Esq., was an owner of part of this shorefront property from 1907 to 1931, when it was sold to William M. Todd.

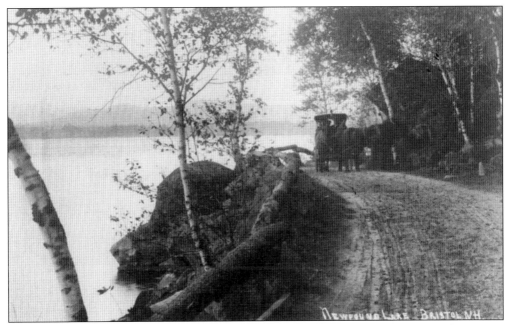

The Ledge Road now known as West Shore Road is shown around 1900. In 1861, this section of road was carved into Sugarloaf Mountain, creating a more direct route to Hebron from Bristol. Hikers can reach the top of the 200-foot-tall ledges by following the Elwell Trail from Wellington State Park.

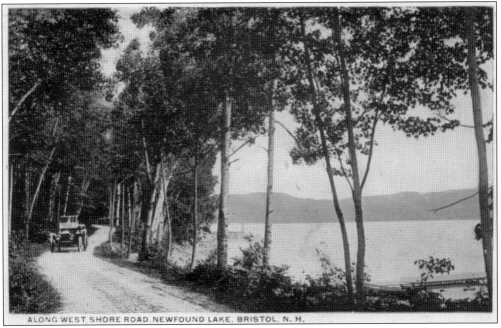

ALONG WEST SHORE ROAD, NEWFOUND LAKE, BRISTOL, N. H.

This postcard, postmarked 1920, shows West Shore Road, with an automobile on the narrow dirt road and a dock on the shore. A drive around Newfound Lake is very scenic and still enjoyed to this day, with much credit due to the Civilian Conservation Corps' hard work on improving roads in the 1930s.

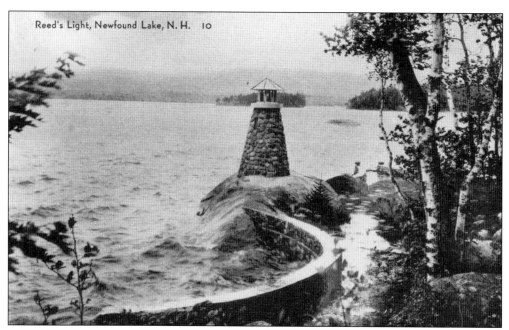

Located on West Shore Road near the Ledges, Reed's Lighthouse was built in 1932 by Boston news photographer A.B. Reed on the point of his summer estate. The postcard is postmarked 1939, and the view is toward the east. Belle Island is visible in the background, with Cliff Island to the right of that.

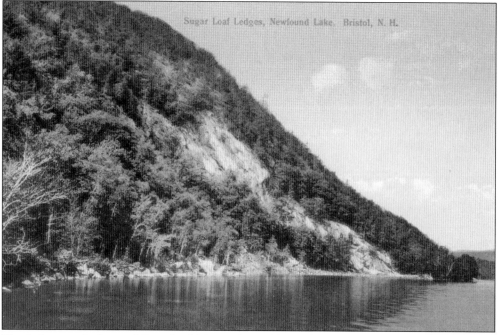

Sugar Loaf Ledges, Newfound Lake. Bristol, N. H.

The ledges at the base of Sugarloaf Mountain on West Shore Road in Alexandria are seen here. At a depth of 182 feet just east of the ledges, Newfound Lake is the deepest lake in New Hampshire—followed by Lakes Winnipesaukee and Winnisquam—making it a popular place for scuba divers. This postcard is postmarked 1950.

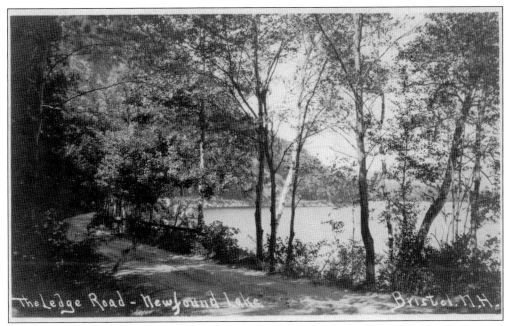

Known as the Ledge Road, this postcard shows what is now West Shore Road by the Ledges. Not far from here, many Indian artifacts have been discovered over the years, including arrowheads and tools. This postcard is postmarked 1922.

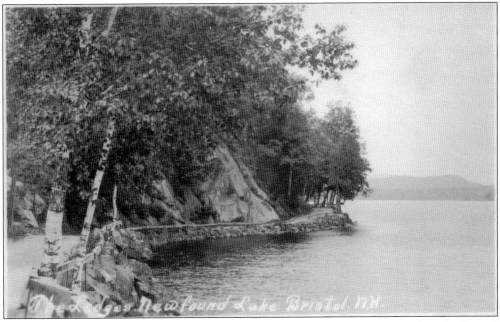

The Ledge Road was originally called Chain Road and was a narrow dirt path at the base of Sugarloaf Mountain on the west shore of Newfound Lake. Prior to 1861, the only road to Hebron from Bristol was on the east side of Newfound Lake, which was a much longer distance.

The Ledges are depicted here as seen from West Shore Road. This must have been a treacherous road to travel in winter with a steep drop-off and little room to navigate between the road and the lake. Visitors must still drive cautiously on this stretch of West Shore Road because of the narrow, winding road and large boulders along the lake.

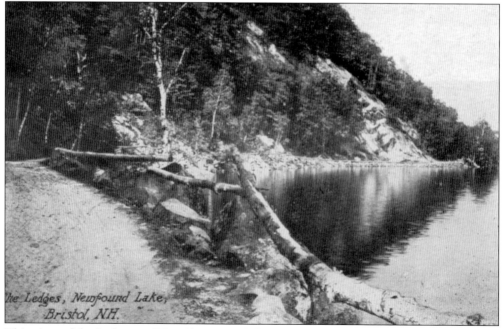

This view of the Ledges on West Shore Road shows logs used for a rustic railing, one of the first man-made guardrails here, obviously necessitated by the extremely steep drop-off next to the road, said to be the deepest part of Newfound Lake.

Six

ISLANDS

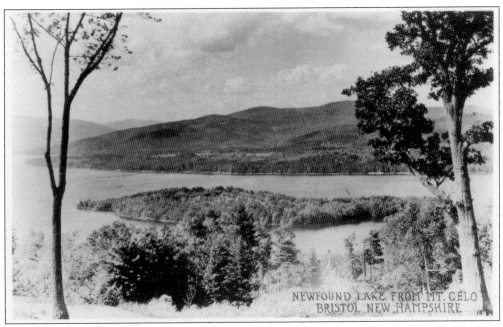

NEWFOUND LAKE FROM MT. CELO
BRISTOL NEW HAMPSHIRE

Shown here around 1937, Mayhew Island is a 50-acre private island located in the southern part of Newfound Lake. It was uninhabited and used for lumber and sheep grazing until 1920, when Groton School Camp (established in 1893) moved its operation here from Squam Lake. The island is now home to the Mayhew Program, a nonprofit boys' summer camp. For more information, readers can visit www.mayhew.org.

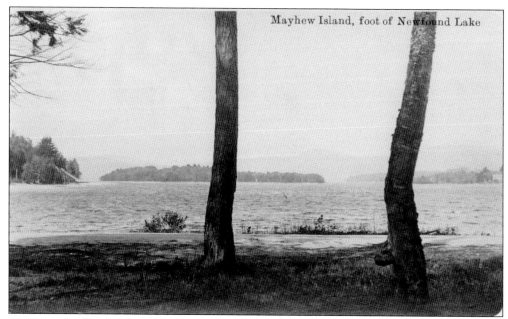

Mayhew Island is seen here from the foot of Newfound Lake in this postcard postmarked 1914. The island was named after William Mayhew, whose father, Peter Mayhew, was instrumental in building the Mayhew Turnpike. William lived on the eastern side of the Mayhew Turnpike in Bristol, near Pike's Point. In the mid–1800s, the island was named March Island until Widow March was forced to sell it for taxes, at which time it was purchased by Zeke Follansbee, who also owned Cliff and Belle Islands.

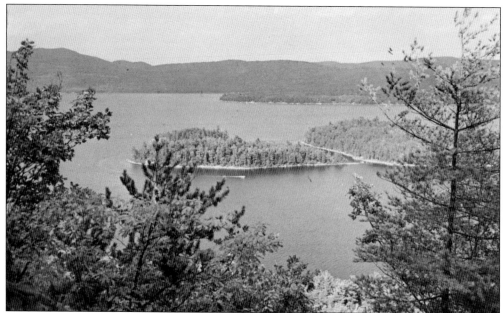

Located next to Belle Island and part of Wellington State Park on the west shore, 10-acre Cliff Island is the second-largest island on Newfound Lake. Cliff Island was once known as Hog Island and later as Moss Island. Like Belle Island, Cliff Island is available for organized youth-group camping. For more information, readers can visit www.nhstateparks.com/wellington.html.

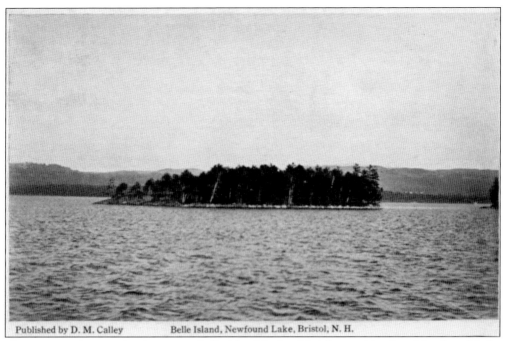

Published by D. M. Calley Belle Island, Newfound Lake, Bristol, N. H.

Shown around 1920, the three-acre Belle Island is the third-largest island on Newfound Lake and located near Wellington Beach on the west shore. Formerly known as Pig Island, it is now owned by New Hampshire and available for organized youth-group camping adventures. For more information, readers can visit www.nhstateparks.com/wellington.html.

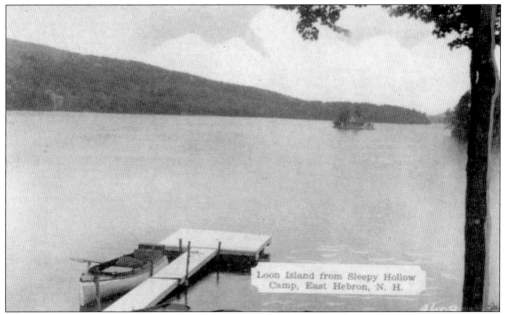

Loon Island from Sleepy Hollow Camp, East Hebron, N. H.

Loon Island, the smallest island in the lake, is located at the northern end of Newfound Lake near Sleepy Hollow Camp in Hebron. A quaint New England–style cottage encompasses most of the island. Occupants must bring their food and all necessities with them from shore. It is a truly unique place to visit.

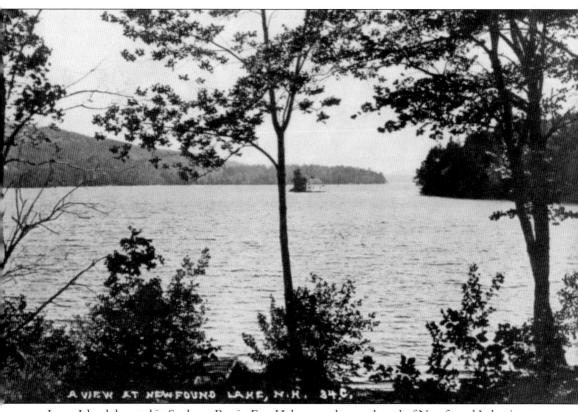

A VIEW AT NEWFOUND LAKE, N.H. 34 C.

Loon Island, located in Sanborn Bay in East Hebron at the north end of Newfound Lake, is seen here around 1920. This vintage postcard image was taken from the shores of Sleepy Hollow Camp looking south across Sanborn Bay. The view from this area remains remarkably the same to this day.

Seven

SUMMER CAMPS

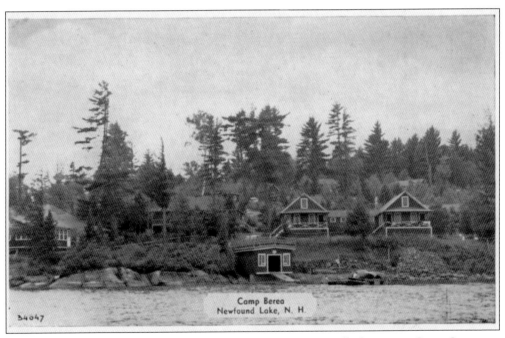

Located at 68 Berea Road in Hebron, Camp Berea was originally known as Camp Sagamore for Boys. Walter F. Prince founded the camp in 1916 near Indian Point on Newfound Lake for youths, adults, and families. In 1945, a group of 15 churches bought the 25-acre property to operate a Christian camp. In 2004, they purchased an adjacent 25 acres, thus doubling the camp's size. For more information regarding Camp Berea, readers can visit www.campberea. net. (CB.)

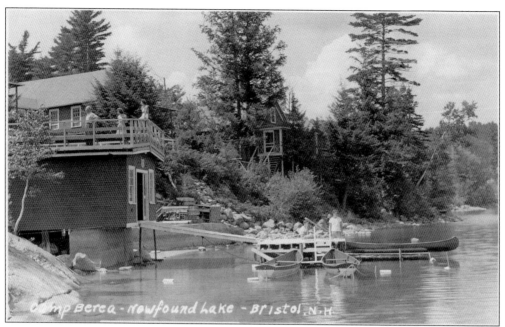

Camp Berea was known as Camp Wah-Keenah when the property was purchased by Jacob Milsner from Walter Prince in the 1920s. Prince subsequently purchased 1,050 feet of shorefront property at the foot of Newfound Lake in Bristol and created the famous Prince's Place resort. Shown here is Camp Berea's beach area around the 1940s. (CB.)

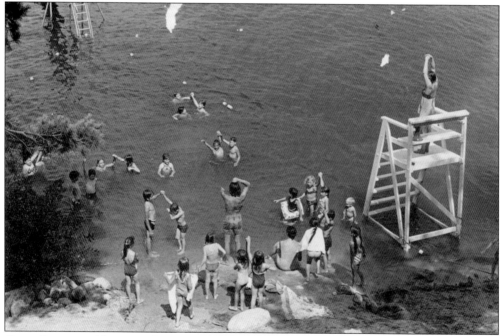

Camp Berea provides a wonderful summer camp program and year-round programs for youth, adults, families, and youth workers while sharing the gospel. Shown here around the 1940s is summer fun with children of all ages enjoying time at the camp's fabulous private beach area on the west shore of Newfound Lake in Hebron. (CB.)

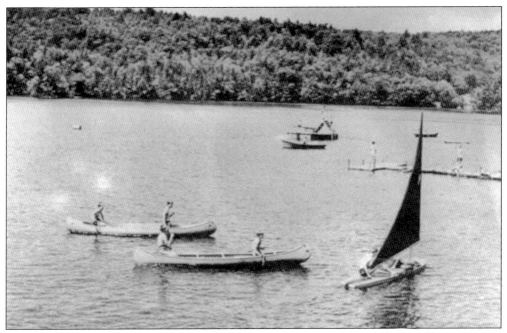

Located on the eastern shore of Newfound Lake in Hebron, Camp Mowglis is a nonprofit summer camp for boys founded in 1903 by Elizabeth Ford Holt, of Boston, Massachusetts. Shown here is a 1950s-era boating and swimming scene. For more information, readers can visit www.mowglis.org. (CM.)

Camp Mowglis borrowed names for its camp buildings from *The Jungle Book*, with the permission of author Rudyard Kipling, who remained involved in the camp's operations for many years. This image shows camp activities around the 1950s. (CM.)

Located at 27 Camp Onaway Drive in Hebron, Camp Onaway was originally called Redcroft. It was established in 1900 by Mrs. Oscar Holt as a summer camp for girls. In 1911, it was renamed Camp Onaway by Mrs. Henry (Mabel Woodbridge) Hollister, who was the director until 1937. This photograph is from about 1930. For more information, readers can visit www. camponaway.org. (CO.)

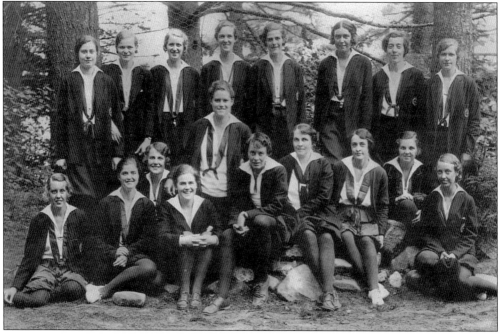

In 1960, Camp Onaway was incorporated as a nonprofit educational trust consisting of devoted Onaway parents and alumnae. The camp counselors are shown around 1931. This camp has been in operation for over 100 years. To mark this milestone, camp historian Helen Greven is writing a book titled *Let Her Strong and Ageless Be: A History of the First 100 Years of Camp Onaway*. (CO.)

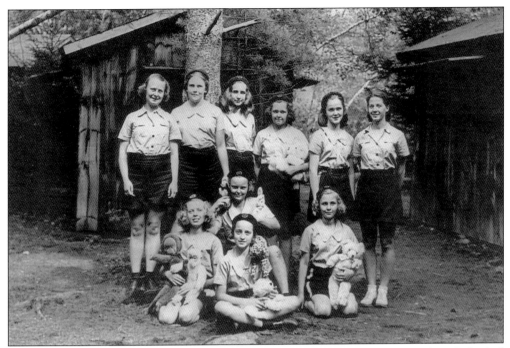

Camp Onaway is a girls' summer camp that is dedicated to the spiritual, mental, and physical development of young women. Carrying on this wonderful endeavor, current director Anne Peterson Connolly was a camper and then a counselor in the 1960s. This photograph of early campers is from 1938. (CO.)

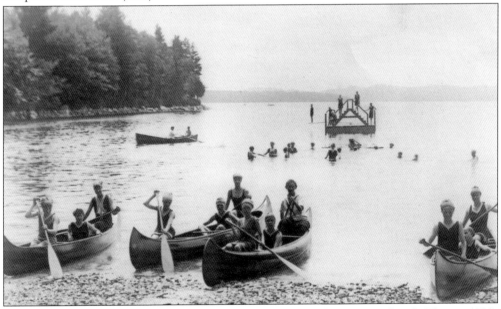

Camp Onaway offers swimming, boating, and canoeing on its large private beach. These c. 1930s campers enjoyed summer days filled with outdoor activities in a beautiful setting on Newfound Lake. However, camp life could not have been easy then for most of these privileged girls used to a genteel upbringing surrounded by modern conveniences and comparable luxury. (CO.)

Located at 19 Pasquaney Lane in Hebron and founded in 1895 by Edward S. Wilson, Camp Pasquaney is a summer camp for boys where appreciation for the beauty of New Hampshire's lakes and White Mountains is encouraged. For more information on this summer camp for boys, readers can visit www.pasquaney.org.

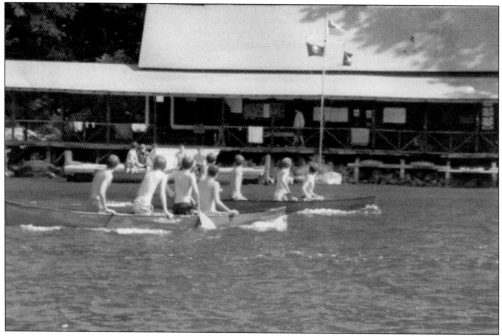

Camp Pasquaney offers a wide variety of activities and outdoor adventures, including canoeing, as seen at the camp's private beach area. Actor Ed Norton attended this camp from 1981 to 1985 and won the Acting Cup in 1984.

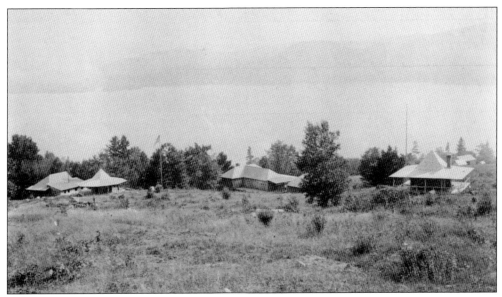

Taken in 1896, this photograph depicts Camp Pasquaney's upper camp, showing the office, dorms, headquarters, and dining hall overlooking Newfound Lake. This boys' camp focuses on competence, character, and community, and it strives to teach the boys to be strong, efficient, confident, and self-reliant. Their days are filled with numerous activities designed to reinforce these characteristics. (CP.)

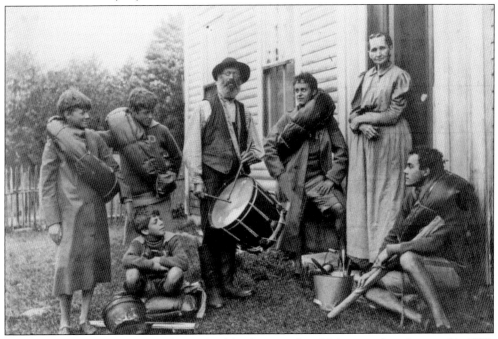

Camp Pasquaney campers are shown in this photograph, which was taken August 11, 1899, during a trip to the house of a Civil War veteran (seen holding a drum) and his wife near Welton Falls. Nature hikes are still an integral of camp life at Camp Pasquaney, and every camper goes on four all-day hikes at Pasquaney's 30-acre campsite in Crawford Notch. The Long Walk takes six days. (CP.)

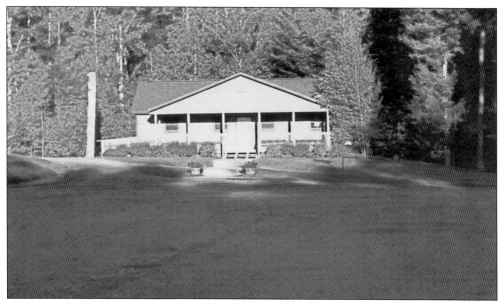

Located at 21 Wicosuta Drive in Hebron, Camp Wi-Co-Su-Ta (the original spelling that is still on the entrance sign) is a popular summer camp for girls. Founded in 1920 by Anna Rothman, it was one of the first sleepaway camps established in the United States. For more information, readers can visit www.campwicosuta.com.

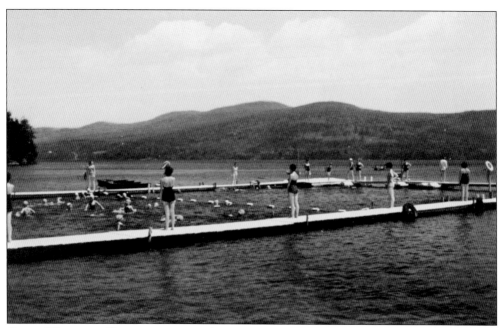

Camp Wicosuta offers numerous outdoor activities and emphasizes skill building and self-confidence in a beautiful lakeside setting nestled in the mountains. As with many other renowned summer camps in the Newfound area, it has been reported that daughters of well-known public figures have attended this popular camp over the years.

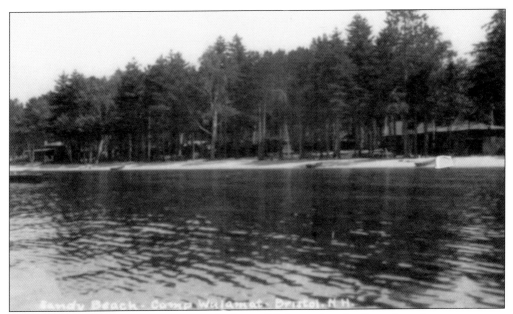

Located on Greenwood Path in Bristol, Camp Wulamat is a family-oriented summer camp owned and operated by the Robinson family and was originally a Boy Scout camp. It is situated on a large, secluded waterfront parcel on the west side of Newfound Lake next to Bristol Shores, formerly Blueberry Shores Campground. This postcard is from around the 1950s.

Located at 1600 Mayhew Turnpike in Bridgewater, Masquebec Hill is a unique, family-sized summer camp for 10-to-16-year-old boys that offers sailing, swimming, canoeing, hiking, fishing, sports, theater, and music. This view is from the camp's one mile of private shoreline. For more information on this summer camp, readers can visit www.masquebec-hill.com.

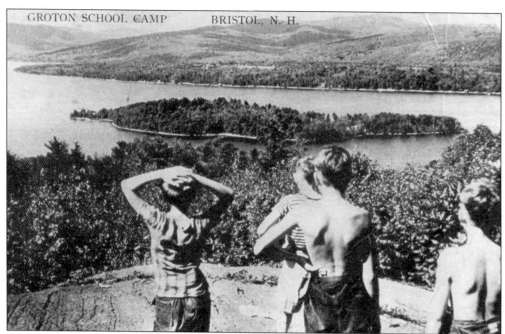

Located on Mayhew Island at the southern end of Newfound Lake, the Mayhew Program is a nonprofit boy's camp originally called Groton School Camp. This camp was founded in 1893 on Groton Island in Squam Lake but moved to Mayhew Island in 1920. Its main objective was to provide underprivileged boys a chance to enjoy themselves in the country, and this wonderful program continues to this day. For more information regarding the Mayhew Program, readers can visit www.mayhew.org.

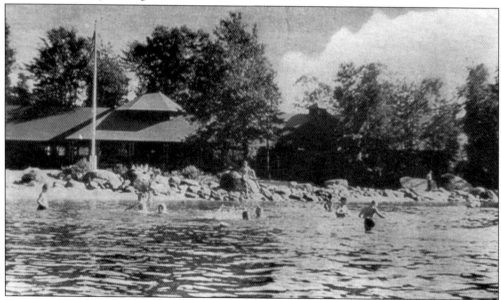

This c. 1930 postcard of the beach area of Groton School Camp shows young boys enjoying the summer fun. It has been known as the Mayhew Program since 1975. Mayhew Island was uninhabited and used for raw lumber and sheep grazing until 1920. Franklin D. Roosevelt Jr. was a camp counselor at this renowned camp in 1932.

Eight

DINING

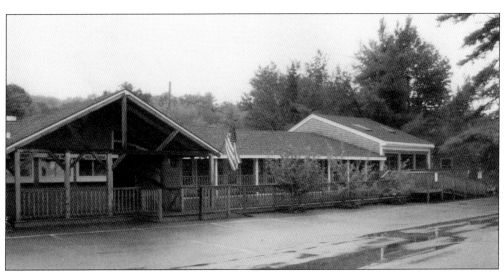

Located at 150 Shore Drive in Bristol and formerly operated as Bullwinkle's Arcade and Darling's real estate office, the Big Catch Restaurant is open May to September. It features casual dining and takeout with a wide selection of New England–style foods—such as seafood, steak, burgers, and salads—with a popular full-service lounge, patio dining, and unparalleled views of Newfound Lake. For more information, see Big Catch Restaurant at www.facebook.com.

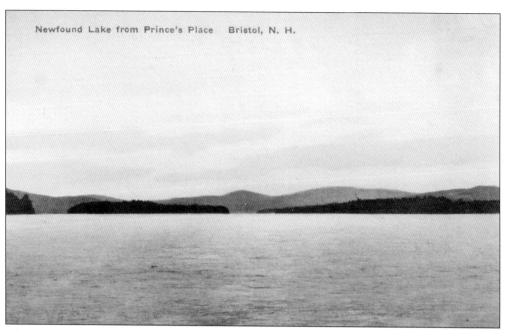

Newfound Lake from Prince's Place Bristol, N. H.

The Big Catch Restaurant offers this panoramic view of Newfound Lake, which remains remarkably the same as depicted in this postcard postmarked 1929. Diners can also arrive by boat to this fabulous restaurant at the foot of the lake, which only adds to its popularity.

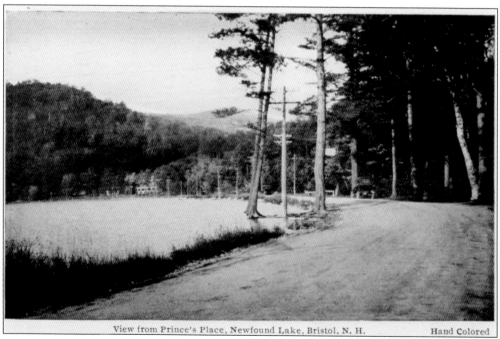

View from Prince's Place, Newfound Lake, Bristol, N. H. Hand Colored

The Big Catch Restaurant is located on the southeast shore of Newfound Lake. This postcard dated 1936 shows Shore Drive in Bristol at the foot of the lake, with a glimpse of the restaurant's original building to the right of the old Mayfair Lodge, now known as Swissview Condominiums.

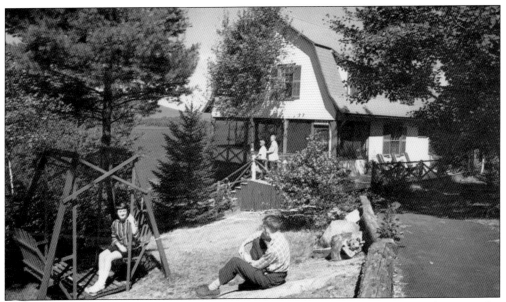

Located at 77 Ravine Drive in Bristol, Ledge Water Steak House offers fine dining and a lounge with unsurpassed views of Newfound Lake. It is the perfect place for weddings and special events. Formerly known as Cliff Cottages, this property was the site of a plumbago mine, which was the source of top-quality graphite for lead pencils in the 1820s–1840s. Henry David Thoreau reportedly spent time here with his uncle who owned a plumbago mine.

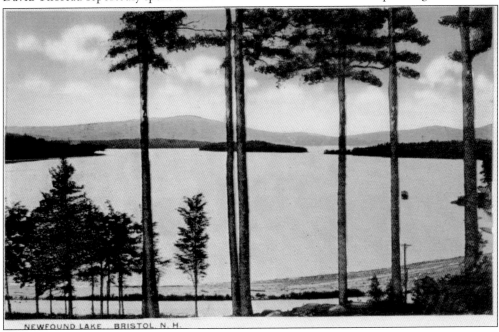

Ledge Water Steak House, formerly Cliff Cottages, enjoys this million-dollar view of Newfound Lake and Mount Cardigan in the distance, shown here around 1950. Owned and operated by Paul and Tami Zareas, the property was exquisitely updated when reopened in 2011 and has an expansive outdoor patio that features fantastic sunset views. For more information, see Ledge Water Steak House at www.facebook.com. (RSC.)

Located at 1777 Lake Street (Route 3A) in Bristol, Basic Ingredients Bakery and Bistro (formerly operated as Ernie's House of Beauty and Pikes by the Lake) was built in 1817 by the Sleeper family. It was a popular lakefront boardinghouse with a dining room, which is now a bakery bistro, and gift shop owned and operated by the Manganiello family since 1988. It offers exceptional homemade baked goods, takeout, and catering. For more information, readers can visit www.basicingredientsnh.com. (GM.)

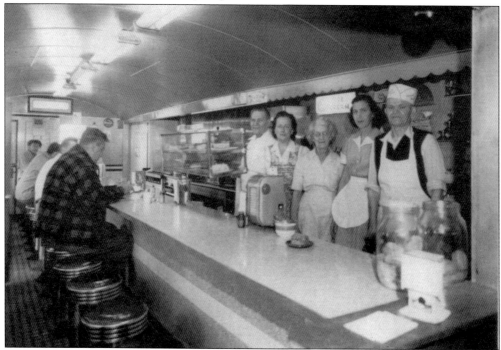

Located at 33 South Main Street in Bristol, the Bristol Diner (formerly known as the Riverside Diner) opened in 1938, as shown here. Owned and operated by the Nialetz family since 2006, this classic eatery offers year-round, indoor-and-outdoor, home-style dining and a lounge overlooking the Newfound River. For more information, see Bristol Diner at www.facebook.com. (JN.)

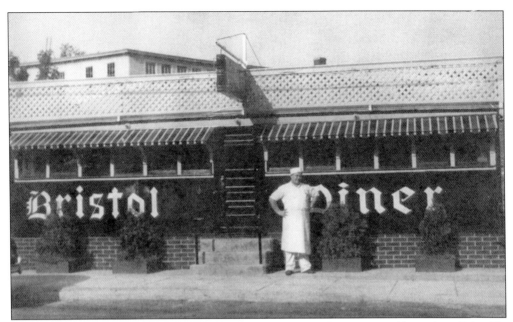

The Bristol Diner was an imitation train car that was ironically transported by train to Bristol in 1937 and opened in 1938 downtown on the Newfound River. This vintage photograph shows the original Bristol Diner at its grand opening in 1938, and it looks relatively the same now after being lovingly restored in recent years. (JN.)

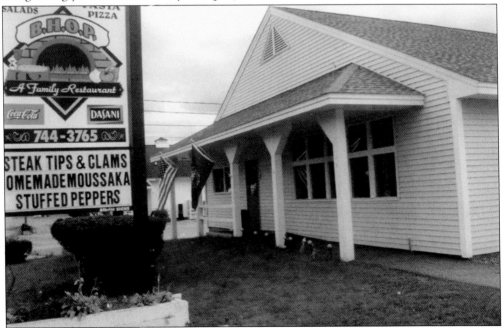

The Bristol House of Pizza, located at 115 Lake Street in Bristol, is a year-round family restaurant. Originally established in 1978 next to Cumberland Farms in downtown Bristol, it was relocated and reopened in 1984 by the Kalampalikis brothers, and has been owned and operated since 1978 by the Raptis family. The eatery specializes in pizza, pasta, seafood, salads, and Mediterranean foods. For more information, readers can visit www.eatbhop.com. (BC.)

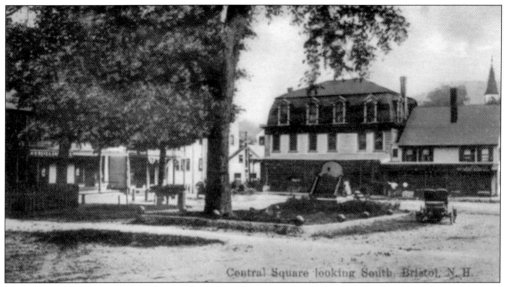

Cornucopia Bakery and Cafe was formerly known as Presidential Grille, Bristol Inn, Bristol Lodge, and Abel's Restaurant. Located at 26 Central Square in Bristol and overlooking the Newfound River, the establishment is open year-round and offers healthy, homemade foods from the bakery and café as well as catering services. For more information, readers can visit www.thecornucopiabakery.com.

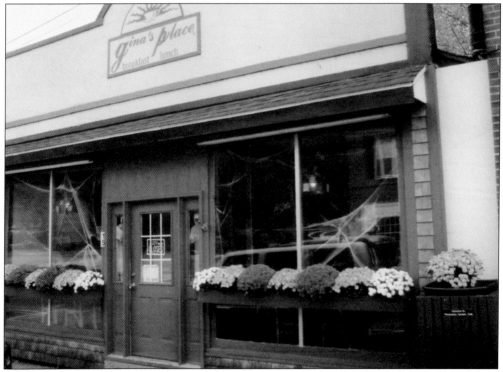

Gina's Place, formerly known as the Sidewalk Cafe, is located at 15 Pleasant Street in downtown Bristol. Owned and operated by Gina Morrison, the café is open year-round, seven days a week and serves fresh, homemade breakfast and lunch. (BC.)

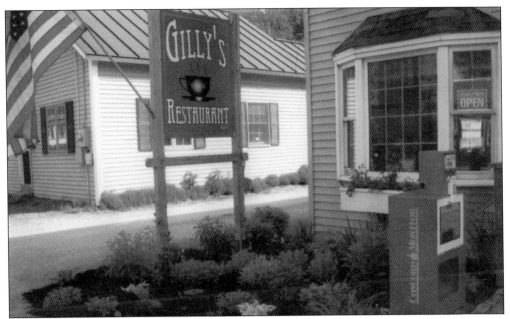

Named for Gwendolyn "Gilly" Bennett, who bought the restaurant in 1984, Gilly's Restaurant is open year-round and has been an outstanding family-owned restaurant for over 30 years. This building located at 101 Lake Street in Bristol was previously a plumbing business owned by a Mr. Pinker and a carpet store owned by Bob Lafond. For more information, see Gilly's at www.facebook.com. (BC.)

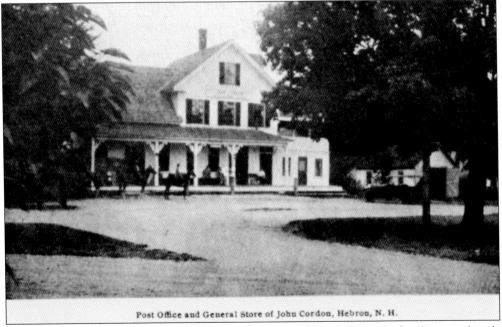

Post Office and General Store of John Cordon, Hebron, N. H.

Hebron Village Store, located at 7 North Shore Road in Hebron, is family-owned-and-operated and serves home-style breakfast and lunch seven days a week all year long. It is the second-oldest village store in New Hampshire. This postcard is from about the 1920s. For more information about this historic eatery, readers can visit www.hebronstore.com.

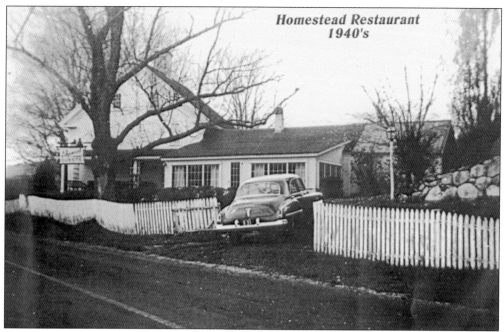

The Homestead Restaurant, located at 1567 Summer Street (Route 104) in Bristol, was the original homestead of Lt. Benjamin Emmons, the first settler in New Chester (now called Bristol). Built around 1788, this is the oldest house still standing in Bristol today. The restaurant offers fine dining and a tavern in a charming atmosphere, as well as catering services. For more information, readers can visit www.homesteadnh.com.

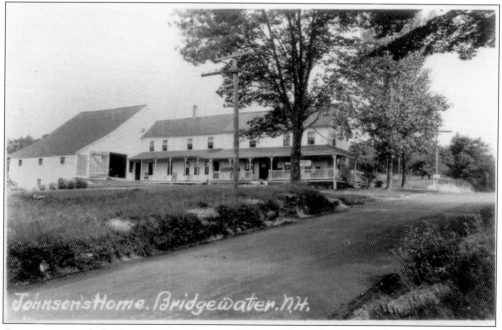

Open year-round, the Japanese Steakhouse and Tavern, located at 367 Mayhew Turnpike (Route 3A) in Bridgewater, offers family dining with dishes from around the world and entertainment on the weekends. For more information, readers can visit www.bridgewater-inn.com.

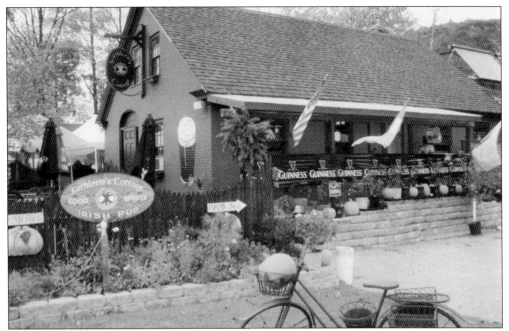

Located at 90 Lake Street in Bristol, Kathleen's Cottage Irish Pub features Irish and contemporary cuisine, offers the largest Irish whiskey selection in New Hampshire, and is open year-round. As one of New England's destination pubs, it offers live entertainment from all over New England and Irish music lessons. For more information, readers can visit www.kathleenscottagenh.com. (BC.)

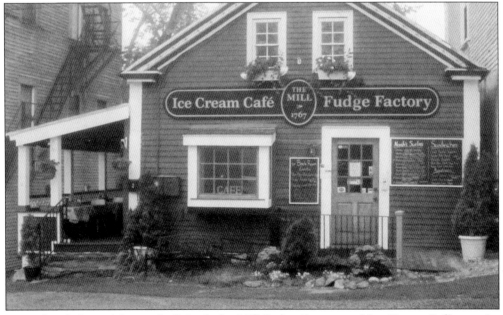

Located at 2 Central Square in Bristol, the Mill Fudge Factory and Ice Cream Café occupies the oldest building in town. It was built in 1767 as a gristmill on Newfound River. Now open year-round, the eatery offers homemade fudge, ice cream, and a café menu with beer and wine. For more information, readers can visit www.TheMillFudgeFactory.com.

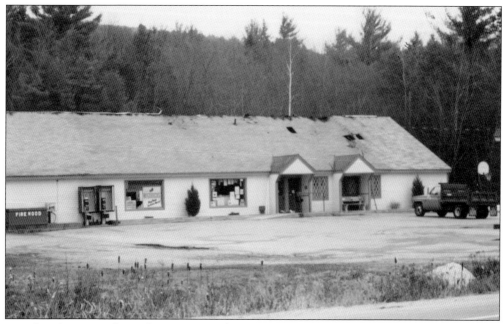

Newfound Grocery, located at 408 Mayhew Turnpike (Route 3A) in Bridgewater, is open year -round with a full-service restaurant and bakery offering homemade foods and catering services in addition to groceries, gifts, and gasoline. It also features live entertainment and an array of beer and local wines. For more information, readers can visit www.newfoundgrocery.com. (BHS.)

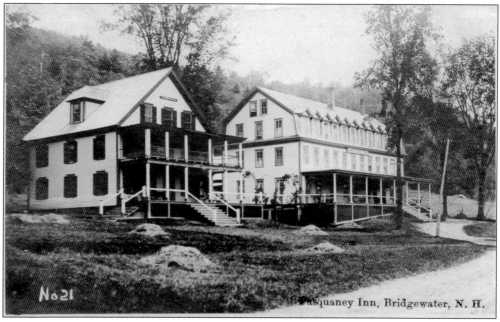

Pasquaney Restaurant and Wild Hare Tavern, located at 1030 Mayhew Turnpike (Route 3A) in Bridgewater, offers fine dining and a lively atmosphere in a charming vintage tavern with sweeping views of Newfound Lake. Diners may arrive by car or boat, adding to its popularity. This postcard is postmarked 1914. For more information about Pasquaney Restaurant, readers can visit www.newfoundlake.com.

Pat's Seafood and Pizzeria, located at 34 Central Square in Bristol, was formerly known as Buzzy's Market. Open year-round, the eatery offers sit-down, family-style dining in a historic building constructed in the 1800s, with delivery, takeout, and catering. For more information, readers can visit www.patsseafoodandpizzaria.com.

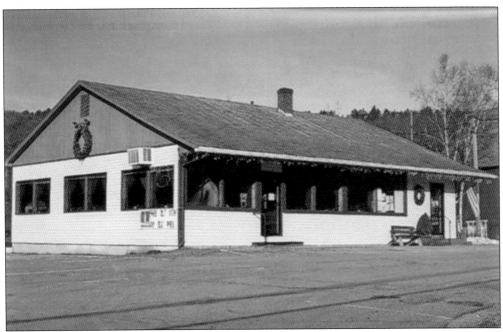

Village Pizza of Bristol, located at 825 Lake Street (Route 3A) in Bristol, was formerly known as Sandy's Restaurant and Mr. Hotdog. This family-style restaurant is open every day year-round and offers homemade Italian and Greek dishes, including spinach pie, pasta, subs, salads, and calzones. For more information, see Village Pizza of Bristol on the Web at www. facebook.com. (DH.)

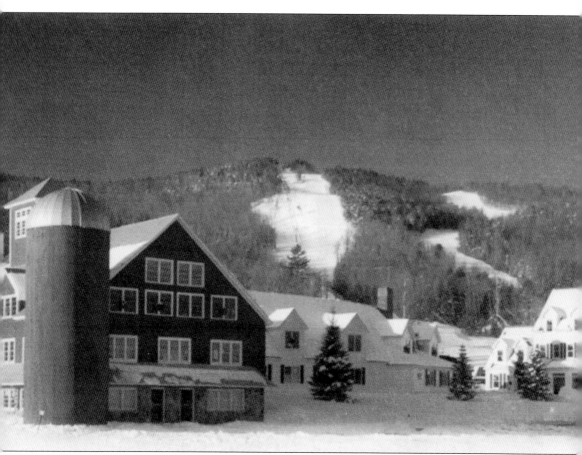

Located at 620 Ragged Mountain Road in Danbury, the Pub at Ragged Mountain Ski and Golf Resort is open year-round and offers delicious home-style cooking and a popular pub overlooking the slopes at the base of Ragged Mountain. Hours vary seasonally, so for more information, readers can visit www.raggedmountainresort.com. (RMR.)

Nine

LODGING

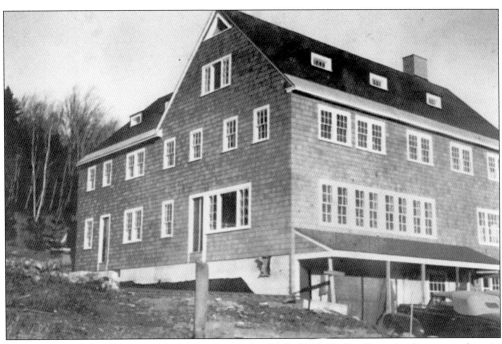

This photograph of the Appalachian Mountain Club (AMC) Cardigan Lodge was taken in 1939. Guests enjoy 50 miles of hiking, snowshoe, and skiing trails right outside the lodge. The lodge is open year-round to members and the public. The AMC was founded in 1876 and is the oldest conservation and recreation organization the country. For more information about the AMC Cardigan Lodge, readers can visit www.outdoors.org/lodging/cardigan. (AMC.)

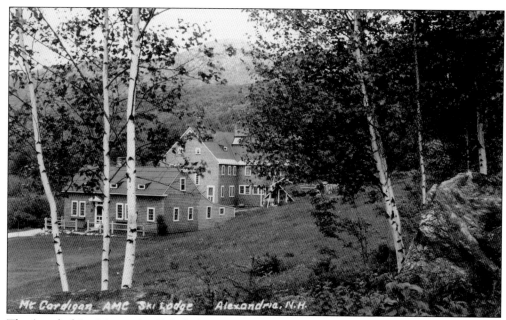

The Appalachian Mountain Club ski lodge is situated on a 1,200–acre, AMC-owned reservation near Cardigan State Park in Alexandria. Cardigan Lodge was built in 1939 and renovated in 2005. The Cardigan State Park is about 5,000 acres.

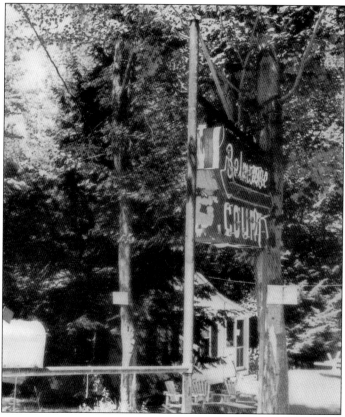

Located at 7 Belmore Court Drive in Bristol on over three acres of land, Belmore Courts was built in 1957 by Harold Waring and originally consisted of 12 cottages and 1,100 feet of shorefront. This cabin resort is still in the same family, and it now rents four cottages, as part of the premises was sold to the Shackett family and another part to Harold's brother Walter Waring. The resort offers kayaks, canoes, and a large raft for swimming, with 375 feet of private beach. (HBW.)

Belmore Courts cabin resort was built on an empty lot that had previously been a dump site used by local rubber-gasket manufacturer RPC in Bristol. Harold Waring's vision of a large cottage colony transformed this neglected piece of land into a wonderful summer resort that has been enjoyed by many generations, and these cottages are still available to rent during the summer season. For more information, readers can visit www.belmorecourts.com. (HBW.)

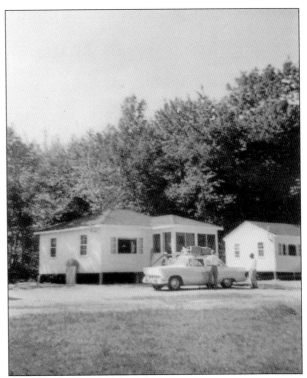

The Bridgewater Inn (formerly known as Blueberry Inn and the Melvin H. Johnson farm) is located at 367 Mayhew Turnpike in Bridgewater. The inn offers quaint lodging in a charming c. 1800 inn and later motel addition with a popular restaurant and tavern on-site. For more information, readers can visit www.bridgewater-inn.com. (JH.)

Coppertoppe Inn, located on a hilltop at 8 Range Road in Hebron, offers luxury lodging and retreat facilities with gorgeous views overlooking Newfound Lake, as shown here. It is open year-round and is child- and pet-friendly. The inn serves daily healthy breakfasts made with ingredients from its organic garden, and it is the perfect place for weddings, reunions, and relaxing getaways. For more information, readers can visit www.coppertoppe.com. (CI.)

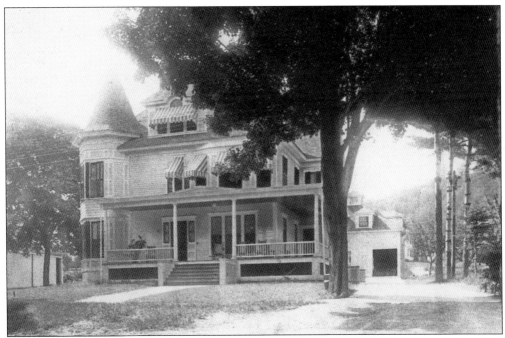

Henry Whipple House Bed and Breakfast, located at 75 Summer Street in Bristol, offers luxurious accommodations near Central Square and is open year-round. Built in 1904 by Henry Chandler Whipple for his wife and three children, the original house was moved one block down the street. Henry died in 1928, but his family lived there until 1961. In 2002, the property was renamed in honor of its original owner. For more information, readers can visit www.thewhipplehouse.com. (TWH.)

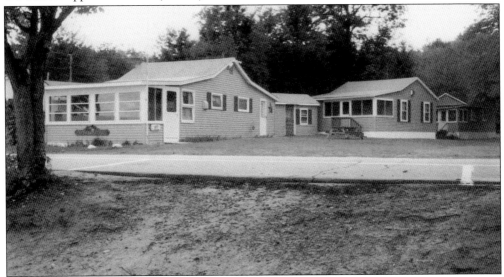

The Lakeview Cottages property, located at 70 Shore Drive in Bristol, has been owned and operated by the St. Cyr family since 1965. Built in the mid-1900s, these charming cottages have spectacular lake views and are walking distance to popular lake-view restaurants. The cottages are still available for rent during the summer season, so for more information, readers can e-mail lakeview70@comcast.net.

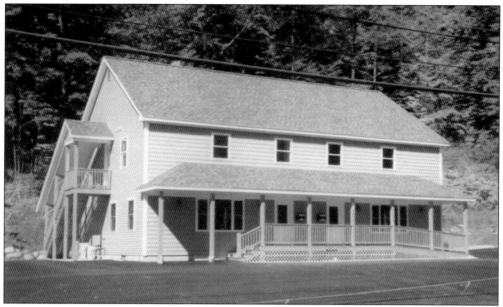

Located at 481 Lake Street, Suite 1B, in Bristol, Lake Area Properties is a real estate office specializing in seasonal and long-term rentals and sales of unique properties around Newfound Lake. For more information, readers can visit www.newfoundrentalsandsales.com. (DH.)

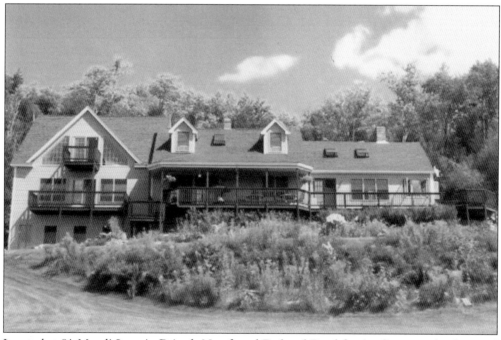

Located at 91 Mandi Lane in Bristol, Newfound Bed and Breakfast is adjacent to land owned by the estate of Dr. Thomas Watson, assistant to inventor Alexander Graham Bell. Nestled on the hilltop on the east side of Newfound Lake and right next to the snowmobile trails, this inn offers lodging with breathtaking lake views and hosts weddings, receptions, seminars, and special events. For more information, readers can visit www.anewfoundbnb.com. (NBB.)

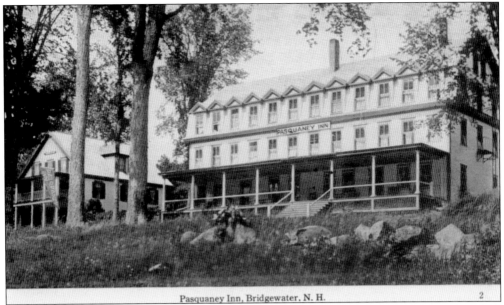

The Inn on Newfound Lake, located at 1030 Mayhew Turnpike in Bridgewater, was originally known as the Pasquaney Inn. The main inn has 28 rooms. Shown to the left, Elmwood Cottage (formerly Bayview Inn) has 12 rooms that cost $9 a night in 1951. Since 1840, tourists have enjoyed a large private beach, dock, and moorings with spectacular lake views and sunsets. This postcard is postmarked 1931.

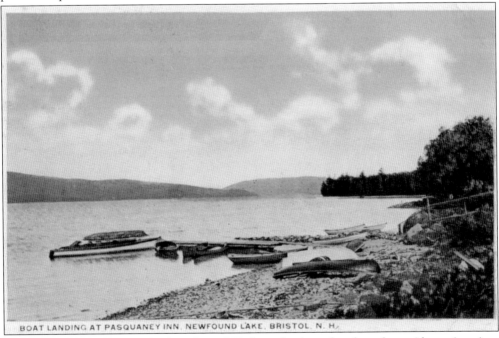

BOAT LANDING AT PASQUANEY INN, NEWFOUND LAKE, BRISTOL, N. H.

The Inn on Newfound Lake has about 240 feet of private beach and provides swimming, boating, fishing, and relaxing. Originally consisting of 185 acres, the property is now 8 acres and offers a limited number of boat moorings for overnight guests. This postcard is postmarked 1919. For more information, readers can visit www.newfoundlake.com.

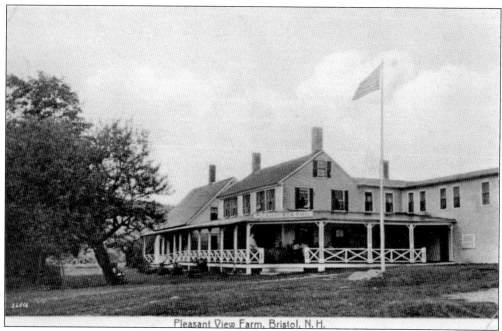

Pleasant View Farm, Bristol, N. H.

Located at 22 Hemp Hill Road in Bristol, Pleasant View Bed and Breakfast (formerly known as the Pleasant View Farm) was built prior to 1832 by local blacksmith Edmund Brown. A deed from 1832 describes the lot: "With cleared land extending to the shores of pristine Newfound Lake." This farm was one of the seven biggest farms in New Hampshire at the time. In the early 1900s, two men asked if they could stay the night, and thus began the business of boarding guests. For more information, readers can visit www.pleasantviewbedandbreakfast.com.

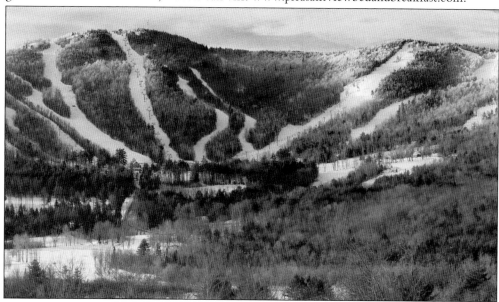

Ragged Mountain Ski and Golf Resort, located at 620 Ragged Mountain Road in Danbury, offers year-round on-site lodging with state-of-the-art amenities at the base of Ragged Mountain and just minutes from Newfound Lake—and only 90 minutes from Boston. For more information, readers can visit www.raggedmountainresort.com. (RMR.)

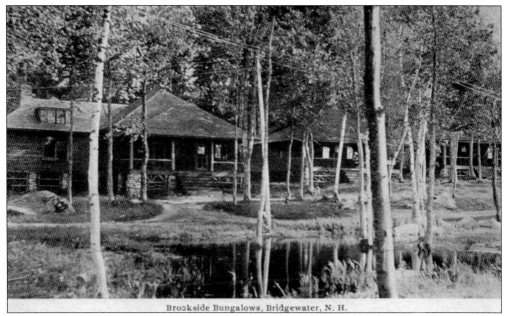

Brookside Bungalows, Bridgewater, N. H.

Located at 86 Whittemore Point Road North in Bridgewater, Sandy Beach Cottages was originally named Brookside Inn and Bungalows. The business offers a variety of lodging, including cottages and chalets in a quiet private beachfront setting overlooking Newfound Lake. For more information, readers can visit www.sandybeachofnewfound.com.

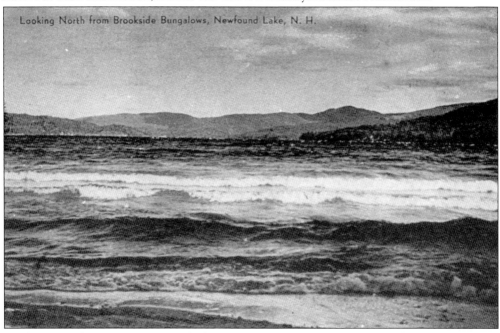

Looking North from Brookside Bungalows, Newfound Lake, N. H.

As shown in this c. 1920s postcard, the Sandy Beach Cottages property (formerly known as Brookside Bungalows) enjoys spectacular lake and mountain views from the private beach. These cottages were built on a large waterfront parcel of land on Whittemore Point just south of Idle-a-While and Pasquaney Inn in Bridgewater and have been popular rental properties for generations of families.

Meadow Wind Bed and Breakfast, located at 41 North Shore Road in Hebron, was a working farm originally built by Capt. Enos Ferrin in 1820. It is open year-round and offers beautiful yet comfortable lodging in a charming vintage setting near the center of Hebron. For more information, readers can visit www.meadowwindbedandbreakfast.com. (MWBB.)

42 COCKERMOUTH CANYON, SHOWING WORK OF EROSION, GROTON, N. H.

Sculptured Rocks Farm Country Inn is located at 363 Sculptured Rocks Road in Groton on the Cockermouth River and within walking distance to Sculptured Rocks State Park. The house was built in 1865 by Artmus Crosby for his wife, Nettie, and as a showplace for the wood from his mill on the river. For more information, readers can visit www.sculpturedrocks.com.

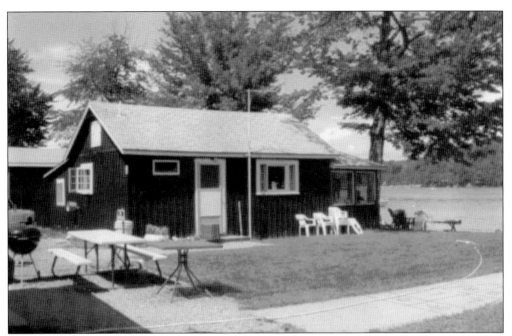

Located at 68–72 West Shore Road in Bristol, the Seven Pups Cottages property has four cottages, with a private dock and 100 feet of private beach on the west shore of Newfound Lake. Weekly rentals are available June through September. For more information, readers can visit www.7pups.com.

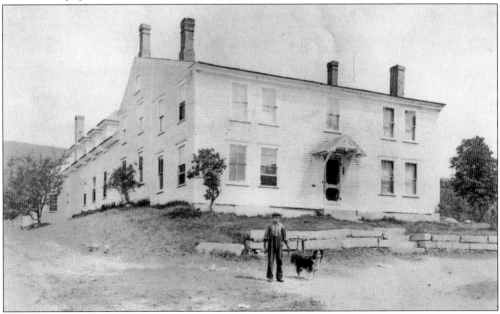

Located at 2 South Mayhew Turnpike in Hebron, Six Chimneys and a Dream is a historic bed-and-breakfast and former stagecoach stop built by Daniel Pike over 200 years ago. Pike's Tavern opened for business in approximately 1799. It acquired its current name after being sold to Peter and Lee Fortescue in 1970. For more information, readers can visit www.sixchimneys. com. (SCBB.)

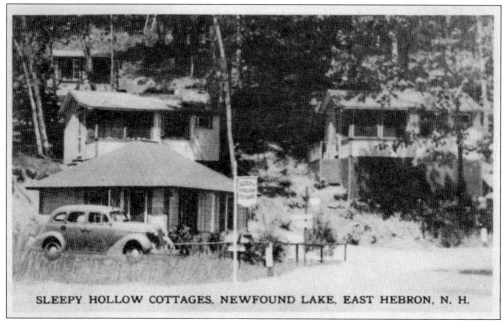

SLEEPY HOLLOW COTTAGES, NEWFOUND LAKE, EAST HEBRON, N. H.

The Sleepy Hollow Cottages property, located on Sleepy Hollow Lane in Hebron, was hand built in the 1930s by Wesley Sanborn. He constructed 13 cottages on a 10-acre waterfront lot. The property was sold to William and Edith Duckworth in the 1950s. In 1978, it became Sleepy Hollow Condominium Association. A cottage owned for many years by the Jacobs family is still available for rent today. For more information, readers can e-mail www.jacoblodge@ myfairpoint.net.

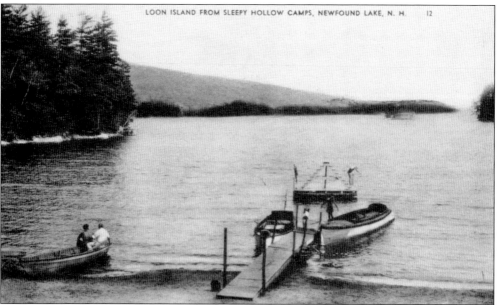

The Sleepy Hollow Cottages property enjoys a large beach with boating, fishing, and bathing. Wes Sanborn, who built these cottages from fallen trees toppled by the fierce Hurricane of 1938, also constructed and operated the Newfound Lake Marina. Sanborn Bay on Newfound Lake was named in honor of this remarkable gentleman. This postcard is postmarked 1939.

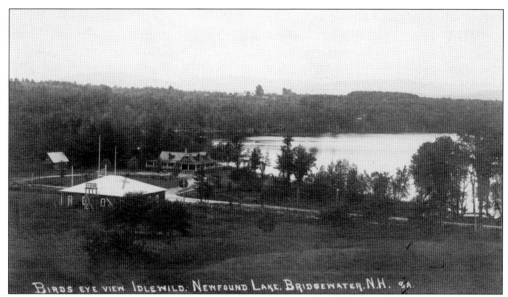

Timberloch Lodge, at 965 Mayhew Turnpike in Bridgewater, was originally known as Camp Idlewild. It was a popular lakefront gathering spot with rooms to rent, a store, and a snack bar. This was a regular mail stop and boat launch for the famous steamer *Stella Marion* in the early 1900s. It still has 10 rental cottages brimming with charm and a sandy, 200-foot private beach. This postcard is postmarked 1917. For more information, readers can visit www.timberloch.com.

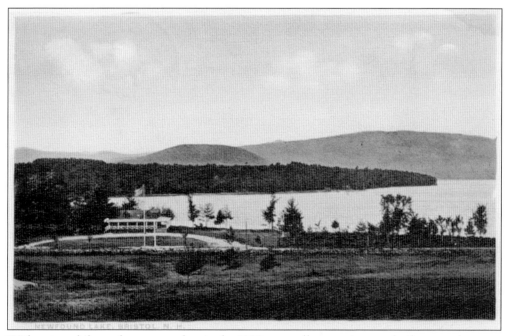

With automobiles and more travelers in the 1920s, a small gas station was built across the street from Camp Idlewild, which burned to the ground around 1930. There are now 10 cottages and a year-around residence called Timberloch Lodge. Three of the cottages are Sears, Roebuck and Co. log kits built in Haverhill, Massachusetts, and assembled on-site in the late 1930s. They remain in place today and are still available to rent. This postcard is postmarked 1915.

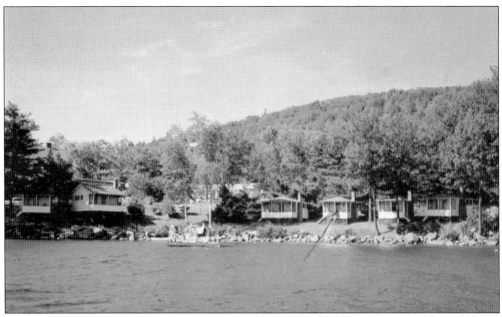

Whip-O-Will Motel and Cottages is located on Route 3A in Bridgewater. This 1966 postcard states, "A deluxe motel with every convenience—TV—Exquisitely furnished—Sandy Beach—Restaurant." This motel still exists, although, over the years, there have been some attempts to replace it with year-round homes. For more information, see Whip-O-Will Motel at www. facebook.com.

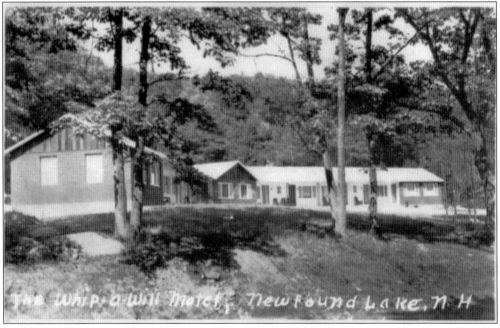

Whip-O-Will Motel is shown in this c. 1950s postcard. It has 10 motel rooms available for rent on the east side of Newfound Lake. This is one of the few remaining motels in the area around Newfound Lake, and its proximity to the lake and gorgeous views have perhaps contributed to its longevity.

Ten

BUSINESSES AND PLACES OF INTEREST

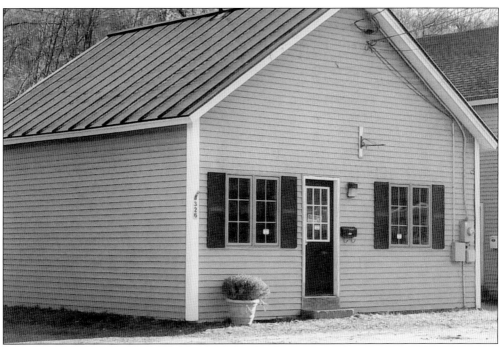

Owned and operated by Beth Christiansen, Newfound Insurance, located at 326 Lake Street in Bristol, provides personalized service for all area insurance needs, covering cottages, homes, businesses, boats, jet skis, snowmobiles, and recreational vehicles in New Hampshire and Massachusetts. For more information, readers can see Newfound Insurance at www.facebook. com. (BC.)

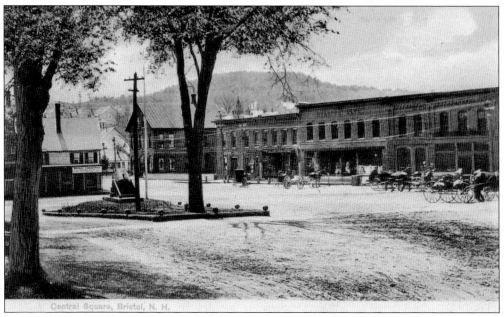

Central Square, Bristol, N. H.

Located at 26 Central Square in Bristol in the building formerly operated as the Bristol Inn, Blue Skies Natural Foods is open year-round and offers health foods, supplements, farm-fresh eggs, and unique gifts and crafts made by local artisans. This postcard is from about 1900. For more information, readers can visit www.blueskiesnaturalfoods.com.

Earthly Treasures Gift Shop and Iron Horse Metal Works is located at 150 Lake Street in Bristol at the rear of a c. 1800s house. It is open year-round and offers unique gifts, artwork, wrought iron crafted on-site, furniture, jewelry, and items handcrafted by local artisans—all American-made. For more information, readers can visit www.earthlytreas.com. (BC.)

120

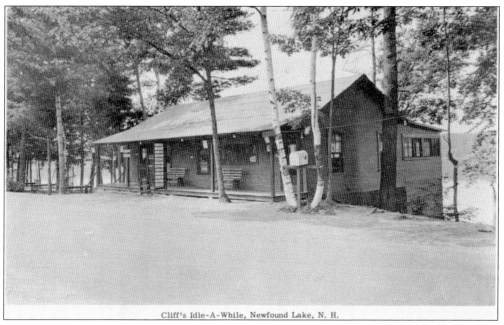

Cliff's Idle-A-While, Newfound Lake, N. H.

Idle-a-While Antiques, located on Mayhew Turnpike (Route 3A) in Bridgewater, was previously a snack bar and general store. Customers arrived by car or boat via the private beach on the east shore of Newfound Lake. This postcard is from about 1920. (BHS.)

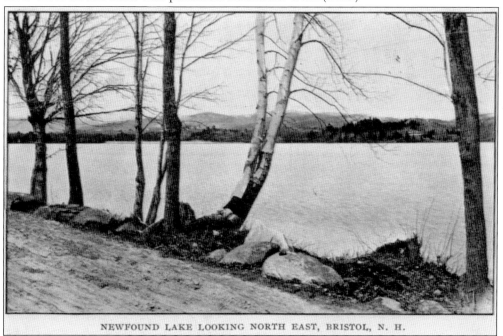

NEWFOUND LAKE LOOKING NORTH EAST, BRISTOL, N. H.

West Shore Marine, located at 315 West Shore Road in Bristol, offers a boat launch, dockside gas for boaters, boat storage, and sales, rentals, and maintenance for all types of watercraft as well as dock systems. Its dock is located on the west shore of Newfound Lake just north of the beach area shown in this postcard postmarked 1912. For more information, readers can visit www.westshoremarine.com.

Our Lady of Grace Chapel, located at the corner of Mayhew Turnpike (Route 3A) and West Shore Road in Bristol at the foot of the lake, was built in 1957 and blessed by Most Rev. Matthew F. Brady on July 6, 1958. Because St. Timothy's Church in downtown Bristol was sold in 2011, this is now the only Catholic church in Bristol.

Holy Trinity Parish Marian Center is located on West Shore Road in Bristol. The Catholic church purchased the dance hall across from Our Lady of Grace Chapel. In 1917, Joseph Ladd built the dance hall called Ladd's Pavilion, later known as Jungle Ballroom and the Casino. The dance hall collapsed on February 16, 2008, from heavy snow. It was rebuilt in 2010 and is available for wedding receptions, parties, and meetings. For more information, readers can visit www.htnh.org.

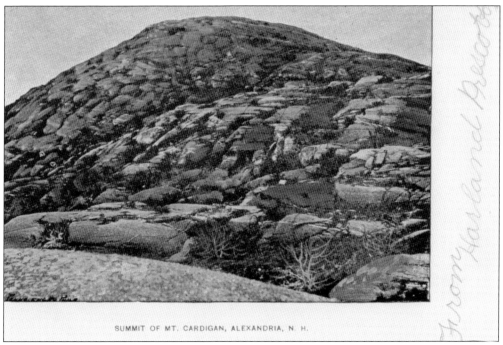

SUMMIT OF MT. CARDIGAN, ALEXANDRIA, N. H.

Shown here around 1890, Mount Cardigan in Alexandria has been a haven for outdoor enthusiasts and hikers for decades. Most of the summit was decimated by fire in 1855, leaving it barren with extensive areas of granite ledges, which give hikers the illusion of being much higher than 3,155 feet above sea level. The Civilian Conservation Corps (CCC) helped to create the alpine ski network still in use today.

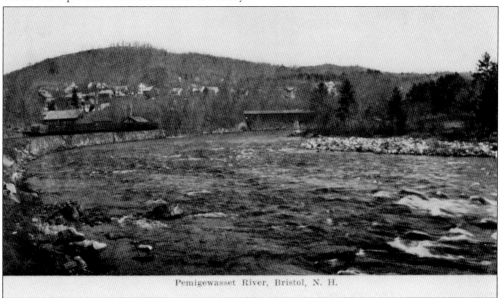

Pemigewasset River, Bristol, N. H.

Pemi-Baker River Adventures, located in Plymouth, rents and delivers kayaks, canoes, and tubes to enjoy on nearby lakes and rivers, including the Pemigewasset River, which runs south from the Newfound River. The Pemigewasset River is depicted in this postcard from the 1920s. For more information, readers can visit www.pbriveradventures.com.

Profile Falls, Bristol, N. H. Hand Colored

Shown around 1952, Profile Falls, located on the Smith River in the town of Hill, was named in the 1890s by Byron B. Tobie. He opened a store and post office, where he was postmaster, but both closed in 1900 when he moved away. Profile Falls is about two miles south of Bristol and reached by a path from the old Excelsior Mill. For more information, readers can visit www. newenglandwaterfalls.com.

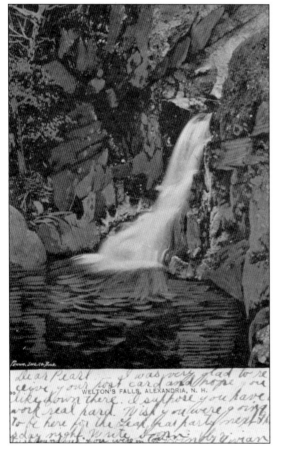

WELTON'S FALLS, ALEXANDRIA, N. H.

Welton Falls, located on the Fowler River at Wellington Falls State Forest in Alexandria, features a 30-foot drop with scattered pools throughout. The falls can be reached by Manning Trail next to the AMC Cardigan Lodge or from Welton Falls Road. For more information, readers can visit www. newenglandwaterfalls.com.

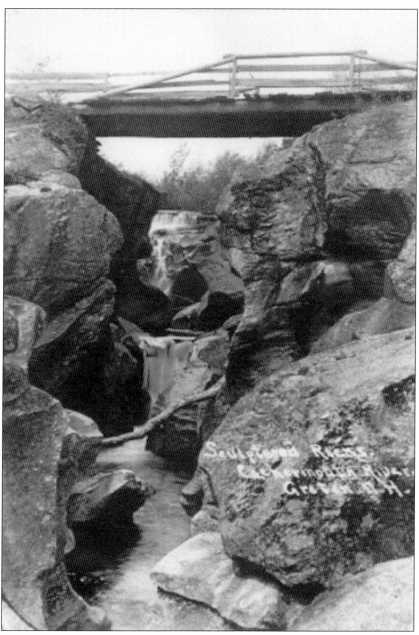

Sculptured Rocks Natural Area geological site is located on the Cockermouth River in Groton just north of Newfound Lake. The site is 272 acres and dates to the last Ice Age about 12,000 years ago, when the Cockermouth River carved a canyon into the bedrock on its way to Newfound Lake. The park is open year-round for recreation, and pets are allowed. Admission is free, and there is no staff at this location. This is a popular place for hikers and nature lovers. The water pools in various places, creating little swimming holes with extremely cold water. The unusual formations throughout Sculptured Rocks make for excellent photographs, and this area is a favorite destination for fishermen and picnickers. It was also an extremely popular place to hang out during the 1960s because of its natural beauty and private setting. For more information, readers can visit www.nhstateparks.org.

BIBLIOGRAPHY

Bingham, Kenneth E. *Groton School Camp.* Charleston, SC: Binghamus Press, 2009.

Collins, Ronald W. *Historical Inventory of Hebron, NH.* Hebron, NH: Hebron Historical Society, 2004.

———. *The History of Hebron, NH: The First Two Hundred Years.* Self-published, 2009.

Curren, Thomas S. *A Bicentennial History of Bridgewater, New Hampshire, 1788–1988.* Tilton, NH: Sant Bani Press, 1988.

Greenwood, Charles E. *History of Bristol 1819–1969: A Sketch.* Meredith, NH: Meredith News Inc., 1969.

———. *Newfound Lake.* Bristol, NH: Enterprise Press, 1976.

Harvey, Janice Hugron. *Around Newfound Lake.* Charleston, SC: Arcadia Publishing, 2001.

Musgrove, Richard Watson. *History of the Town of Bristol, Grafton County, New Hampshire.* Vols. 1 and 2. Bristol, NH: R.W. Musgrove, 1904.

Pattee, F.L. *Pasquaney Echoes.* 1893. Reprinted. Charleston, SC: Binghamus Press, 2009.

Shattuck, Bernard F. *A Little History of a Small Town: Alexandria, New Hampshire.* Self-published, 1982.

BRISTOL HISTORICAL SOCIETY

Bristol Historical Society, located in the Old Engine House at the corner of South Main and High Streets in Bristol, New Hampshire, was formed in 1965 by a group of residents dedicated to preserving the rich history of their town, which includes Newfound Lake. Newfound Lake, as the primary water source, and Newfound River played large roles in the development of industry in Bristol. There were as many as 100 members originally, but membership has dwindled to a small number of residents who are carrying on the original goal of preserving as much history of the town as possible. The society is located in the upper level of the Old Fire House on High Street and has a fascinating museum with a vast collection of books, manuscripts, relics, prints, and *Record Enterprise* newspapers dating to the 1800s in addition to meeting rooms and office space. The society has meetings once a month, and new members are always welcome. For more information about this wonderful nonprofit organization and to learn more about Bristol and Newfound Lake, readers can visit www.bristolhistoricalsociety.com.

DISCOVER THOUSANDS OF LOCAL HISTORY BOOKS
FEATURING MILLIONS OF VINTAGE IMAGES

Arcadia Publishing, the leading local history publisher in the United States, is committed to making history accessible and meaningful through publishing books that celebrate and preserve the heritage of America's people and places.

Find more books like this at
www.arcadiapublishing.com

Search for your hometown history, your old stomping grounds, and even your favorite sports team.

Consistent with our mission to preserve history on a local level, this book was printed in South Carolina on American-made paper and manufactured entirely in the United States. Products carrying the accredited Forest Stewardship Council (FSC) label are printed on 100 percent FSC-certified paper.